T0365335

From Art to Empowerment

How Women Can Develop Artistic Voice

Annette Luycx

Archway Publishing books may be ordered through booksellers or by contacting:

Archway Publishing
1663 Liberty Drive
Bloomington, IN 47403
www.archwaypublishing.com
1 (888) 242-5904

Image Caption and credit:
Guerrilla Girls, Do women have to be naked to get into the Met. Museum? 1989
Copyright © Guerrilla Girls, courtesy guerrillagirls.com

ISBN: 978-1-4808-8496-0 (sc)
ISBN: 978-1-4808-8497-7 (e)

Library of Congress Control Number: 2019918656

Print information available on the last page.

Archway Publishing rev. date: 01/23/2020

Dedicated to Sharon Johnson PhD
Former Graduate Director of the MA in Art Education Program at MICA, USA

She had the vision and inspired me to write this book.

The doors to the world of the wild Self are few but precious. If you have a deep scar, that is a door, if you have an old, old story, that is a door. If you love the sky and the water so much you almost cannot bear it, that is a door. If you yearn for a deeper life, a full life, a sane life, that is a door.

—Clarissa Pinkola Estés, *Women Who Run with the Wolves: Myths and Stories of the Wild Woman Archetype*

Contents

1. "What else is there to learn in order to become a real artist?"1

2. Why Women?5

3. The Artist's Journal: Mining Inspiration from Your Inner World21

4. How to Make a Collage27

5. Your Twelve-Week Workshop33

 Session 1: Images Behind Words: Accessing the Imagination...................40

 Session 2: Metaphors and the Meaning of Images...................48

 Session 3: Memories54

 Session 4: Colors60

 Session 5: Dreams and Nightmares...................66

 Session 6: Feelings74

 Session 7: Spirituality and Personal Symbols82

 Session 8: Meaning and Materials90

 Session 9: Abstract Art...................................98

 Session 10: Mixed Media...................................104

 Session 11: Try Again or Experiment!112

 Session 12: Preparing Your Exhibition...................120

6. To Conclude127

7. For Further Work...................................135

Appendix A ...138

Appendix B ...140

Relevant Books..144

References ...146

About the Author ...151

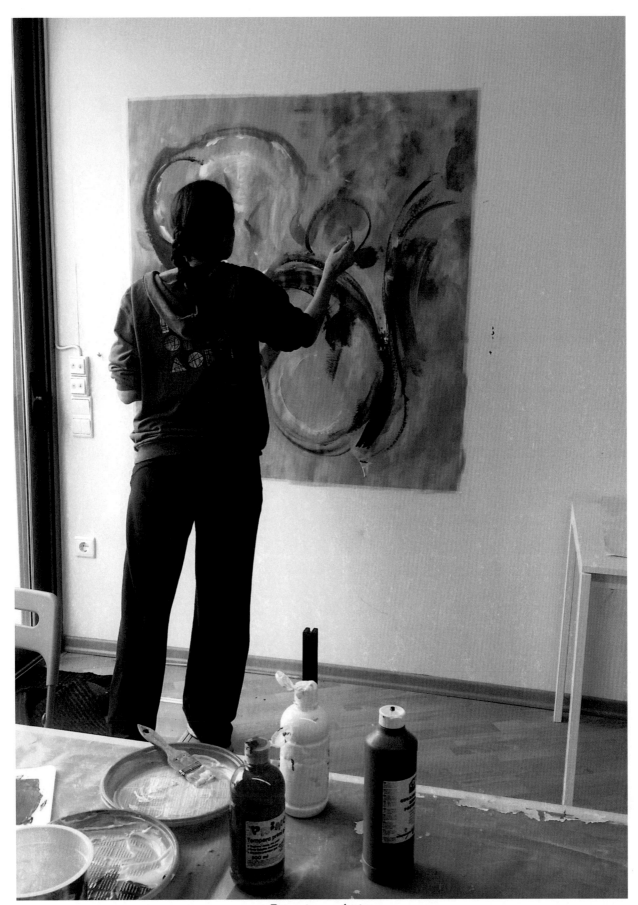

Becoming an Artist

1. "What else is there to learn in order to become a real artist?"

Sometimes a random question fleets by as you smile politely, not paying close attention to it. But that didn't happen with this question. It stayed in my mind for days, weeks, refusing to go away. It found fertile ground in my thoughts and started to sprout. A question from my women collage art students set in motion the writing of this art methodology to develop artistic voice in adult women. It was a question that touched me and that maybe I'd been waiting for as I'd realized that these women were ready to start generating their own themes and images and discover their own ways in art making.

As a self-employed artist and art educator from the Netherlands but living and working in Athens, Greece, for nearly three decades, I have taught various art workshops to adults (mostly women) in Greek and English. Collage art is a fantastic way to teach art making to beginning adult art students. Over time, I have developed several collage and mixed-media workshops for adults. They always cover twelve weekly sessions. Three months is a good time span to engage in an art workshop and learn and practice something new. Each session starts with a PowerPoint presentation of the work of a well-known artist. I use slides of characteristic work of a specific artist to point out elements of formal composition and personal style (e.g., "watch the shapes of Matisse," "the compositions of Lee Krasner," "perspective in the work of Hamilton"). After showing them the slides, my students make a collage or work in mixed media in the style of the artist they have just seen.

After participating in three of my art workshops, one student asked, "What's next? How do we continue from here? This cannot be the end; there must be more to learn. What else is there to learn in order to become a real artist?"

This question guided me to create a new workshop. No slides or examples this time. This workshop was called "Becoming an Artist: Art as a Process." The workshop fostered the discovery of a personal visual language through working on an issue of personal interest and using cut-and-paste collage and photomontage techniques. The main goal of this workshop was for my students to develop artistic voice.

They had to start thinking of art as a process in which they were responsible for generating ideas and images that held personal meaning, and they had to experiment with self-directed ways of using collage materials instead of looking at me as the source for their ideas about what to make and how. I told my students that in this workshop, they had to be like the sun and produce their own light, not like the moon that reflects light coming from another source. This was a metaphor for the past collage workshops where they imitated famous artists. My main goal was to bring them to the source of artistic expression: their own personal narrative. In order to help them make the connection between their narrative and their imagination, I emphasized that they should look for images behind the words they used to describe the issue of personal interest they chose to work on during the workshop. In order to teach them how to become real artists, I filtered the process of becoming an artist down to twelve consecutive sessions, breaking down the multidimensional reality of creating art in such a way that my students would understand the nature of each dimension but also how they operate all together. The students who signed up for the afterwork evening sessions were all Greek women, in their forties and fifties, hardworking and well educated, and eager to learn what art making really is about.

During the twelve-week process, I closely monitored the artistic process of three women in the workshop. I wanted to analyze their artistic and personal development. I did this to see what kind of development in artistic ability and self-identity would occur in these students as a result of my teaching strategies in the workshop. This qualitative case study was part of my graduate studies in art education.

The whole group consisted of seven women. The three students I asked to participate in my case study had been taking lessons with me for a few years, I knew them well, and they were enthusiastic about participating. Every week, I wrote down my observations and impressions during sessions and photographed their work. At the end of the twelve weeks, I analyzed my observations, the artwork, and the artist journals of these three students. I interviewed them for an hour to hear how they had experienced the workshop. In my qualitative case study, I focused on the unfolding of these women's imaginative thinking and their creative skills in using materials and executing their artwork. I considered this to be development of artistic ability. And I looked for increase in knowledge, understanding, and insight of their self-awareness and of their personal narrative of self (what is meaningful for them), as development of self-identity. I reckoned that artistic voice, that unique and recognizable artistic style each artist has, consists of these two elements. Defining these concepts in this way sharpened my focus during observations and my analysis of the artwork.

The three participants I observed and interviewed during the workshop had professional careers and were economically independent. They were Caucasian Greeks. They shared similar backgrounds and interests: they were middle class, educated, and between forty-eight and fifty-six years old. They also shared cultural interests such as attending movies, theater performances, and art exhibitions. At the same time, the three women had totally different personalities and styles of working. They were eager to learn, asked me questions during sessions, and worked at home between the weekly lessons. They were excited about the

prospect of discovering their own ways in art making and were responsive to assignments. There was also good communication on a personal level. There was a mutual respect and a lot of trust.

The interviews I had with them revealed how the students discovered the links between their thinking process and artistic expression. Excerpts of these interviews provide lively material of personal experience in the book. In order to protect their privacy, I have changed the names of these students, share no further information, and show no pictures of them.

This art workbook consists of the twelve dimensions of personal artistic expression I designed and the art methodology and teaching strategies I invented to help women who like making art understand what they need to develop in order to become "real artists." The book clarifies the process of artistic and personal development the women went through by citing their own words and showing their work. Through visualizing their personal narrative, the women discovered what is meaningful for them. Finding images behind words and connecting those images with colors and feelings opened new magical worlds for women who wanted to learn more and become real artists.

From Art to Empowerment: How Women Can Develop Artistic Voice is a workbook about self-discovery through art. It teaches women artists-to-be how to use writing and visualizing for art making. It provides a method to guide women to find their unique personal artistic expression through going on a journey into their inner world. Two techniques are the basis of this book: visualization of personal issues by consciously using the imagination, and journaling to keep track of the artistic process. By keeping an artist's journal, women can explore their personal issues in writing, but they can also use their journals to make sketches, small studies, and stick in significant images, pictures, articles, or whatever is relevant for them. Through self-enquiry, asking self-reflective questions, and researching the answers in writing, as a kind of inner dialogue, they can explore a personal issue, find related images, and work out ideas for their artwork. By verbally and visually exploring what is meaningful to them, they realize that their life experiences and reflections about them are the basis of their personal unique artistic expression, of their artistic voice. That is what they should learn in order to become real artists.

Tina, *Woman Is Like the Sea*, photomontage

2. Why Women?

Why does this art workbook address women in particular? A possible reason could be that in twelve years of teaching weekly collage and mixed-media art techniques to adults, my workshops consisted nearly completely of women (98 percent). When I say *women*, I mean all kinds of women and of all ages. My youngest student was seventeen, and my oldest was eighty-five. They were Greek, Greek American, American, African American, British, Greek British, Egyptian, Dutch, Greek Dutch, Chinese, Russian, South African, Mexican, Israeli, Lebanese, Indian, and Australian—in other words, women from all over the earth. All these women were attracted to the idea of discovering their own subject matter and finding their own style in art. They loved to cut out photographs they liked and then make their own compositions. They wanted to go on a journey with me through their inner landscape, discover the gold (a personal issue that made their hearts beat faster), and learn how to express that in their own ways.

But why were there so many women in my workshops? What is it about art that attracts women? Maybe women are more in sync with their feelings and imagination, and men are more rational? But if this were true, how is it possible that although women make up a majority of art students everywhere, fewer women than male artists are exhibiting their works in art galleries and museums, and most professional artists are men?[1]

In 2007, the *New York Times* had an article about why adult classes of all sorts seem much more popular with women. Tennis classes, writer's classes, triathlon classes—all were 65–95 percent women.

> In New York City, in many (if not most) adult courses, the women are numerous and the men are few—for approximately the same reason that men behind the wheel don't ask for directions: it goes against the male brain to acknowledge ignorance about a subject, said professionals who organize classes! Professionals who oversee classes in New York suggested that men have a tendency to avoid group instruction, particularly beginner classes, because they think they should already know all about, say, sports or wine. Those who do seek instruction, they said, generally prefer private sessions.[2]

Men already know more—or *think* they do. Therefore there's no need to take classes. Why admit you are ignorant? Maybe art classes teach skills that don't seem concrete enough for men. Men like goal-oriented and practical activities like sports and constructing things. Women like process-oriented activities like art and education.

But perhaps that is not the only reason women go to art workshops and men don't. It also has to do with a much deeper cause: with the position of women in society and with women's socialization. Women aren't valued for what they do, simply because they are women. Every day, women face the consequences imposed by the patriarchal society that are discrimination and oppression, and they live fearing violence and rape. In all their endeavors, they face the patronizing, hostile attitude of the established male cultural elite, whether it's in education, politics, science, health care, or art, etc. Women are the devalued sex, as seen from the point of view of men. Anything female is less worthy than male, and this concept has infused society. I believe a key way to deal with the consequences of this gender-biased system is personal empowerment. By refusing an oppressive system that excludes women's experiences and perspectives, growing into self-awareness, and developing a strong self-identity that has the power to find creative and original solutions, a woman can find a modus vivendi that fits her needs.

Many of you might say, "How can this be a book for women? Which kind of women? Young? Old? Black? Rich? Working?" I use this abstract concept of women so that all those humans who feel they are represented by this abstract word feel connected to the message of this book. This book is about self-identity and becoming self-aware through art making. It is about an inner process; it doesn't want to compare women or address a lived reality of a particular group. Every individual woman using this book will discover her own singular process of becoming a woman artist for herself. In this, I agree with what Lena Gunnarsson wrote in 2011:

> It is possible to think of women as a group on a global level, because although the gender structure looks different in different locations, it possesses so much internal coherence so as to deserve to be thought of as one (differentiated) whole.[3]

She also says that there is something disadvantageous about all women's lives, and this something has to do with their being women. Stating that women share a common position as women is not the same as saying that all women are the same.

Women aren't valued for what they do, and the same counts for their art. As Judy Chicago says, "The truth is that for centuries women have struggled to be heard, writing books, making art and music and challenging the many restrictions on women's lives. But their achievements have been repeatedly written out of history."[4] Virginia Woolf wrote, "For most of history, Anonymous was a woman." BBC's recent series *The Story of Women and Art* shows that there were very many women artists in the history of art! It looks like for hundreds of years, there was a very strong control over the art historical canon, and the male-dominated establishment didn't want women written into it.

We don't need to go far back in history to see that. If we look at the beginning of the twentieth century, the beginning of "modern art," it's all men. Cubism, futurism, dadaism, and all the other great world-changing *-isms* were brought about by "talented" men, by "geniuses" in their fields. No women? There were of course plenty of women painting, making sculpture, and inventing new ways of expression, but only some of them entered art history—as the muses, models, and wives of men rather than as contributors to this major revolution in art. Gabriele Münter is known as the girlfriend of Wassily Kandinsky, Sophie Taeuber is the wife of Jean Arp, and who knows Sonia Delaunay, or Lee Krasner (the wife of Jackson Pollock)? These artists were just as good and special as their partners.

Linda Nochlin (an American contemporary art critic) wrote a landmark article in 1971, during the period of second-wave feminism,[5] "Why Have There Been No Great Women Artists?" It is considered to be one of the first major works of feminist art history. In this essay, Nochlin explores the institutional (as opposed to the individual) obstacles that prevented women in the West from succeeding in the arts. The Guerrilla Girls,[6] with their actions, make visible the extent to which women in the art world are being discriminated. They have made posters with all the facts from their research. "Women artists are paid 30 percent less than male artists." "Less than 5 percent of the artists in the Modern Art Section of the Met are women, but 85 percent of the nudes are female."

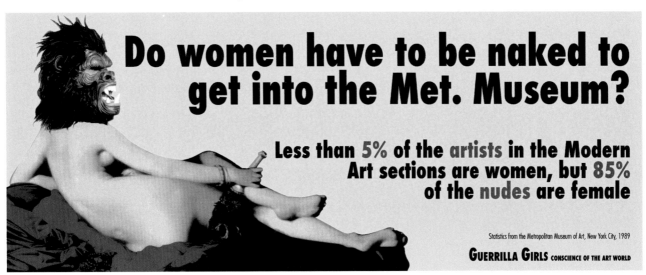

Guerrilla Girls, *Do Women Have to Be Naked to Get into the Met. Museum?* 1989.
Copyright © Guerrilla Girls, courtesy guerrillagirls.com.

In her 1949 book *The Second Sex*, French writer and philosopher Simone de Beauvoir identifies the social construction of woman as the quintessential *Other* ("He is the subject, she is the other") as fundamental to women's oppression. According to de Beauvoir "humanity is male, and man defines woman, not in herself, but in relation to himself." The Other is by definition opposite, lesser, incidental. According to de Beauvoir, women are objectified by men. Being treated as objects of desire, every form of integrity or agency is denied to them. You might say, "But that was written in 1949!" However, think about it for a minute. Isn't it true

that Western culture sexually objectifies the female body? Isn't it true that women never seem to escape the "eternal gaze" that judges their youth and beauty, even in middle and old age? I believe it still is a hard task, especially for young women, to be female in a culture that sexually objectifies the female body. Some women internalize that external gaze to the extent that they develop eating disorders or a severe loss of confidence and voice. That statement from 1949 is still valid! I think it means that girls and women are still being encouraged to think and behave toward their bodies. De Beauvoir also wrote, "One is not born, but rather becomes a woman." According to de Beauvoir, women are socialized to be women: to be attentive to the needs of others, to be pleasant, to smile, and to be "pretty." British art critic Laura Mulvey said women are socialized in terms of their "to-be-looked-at-ness." This influences not only their possibilities in life but also the view they have of themselves. In older women, this fact might bring about transformation because as they are rejected by society due to their "changing" appearance, they are challenged to establish themselves as subjects, developing their lives, taking initiatives, and being creative.

That sounds easy, but it is not so easy. Therapist Sarah Pearlman[7] writes that in midlife, the transformative reality of the combination of age and gender challenges the confident sense of self a woman finds in her youthful body and appearance. Feeling she is dependent on outside approval for a sense of worth, her value rises or falls with her sense of how well she is measuring up to an external norm of youthful beauty. She calls the developmental female transition that begins between the ages of fifty and sixty and that is marked by the sudden awareness of the acceleration and stigmatization of aging "midlife astonishment." It is characterized by "feelings of amazement and despair" at the diminished physical and sexual attractiveness and other losses and changes encountered. According to Pearlman, this transition can initiate a disruption of sense of self or identity and "result in a severe loss of self-esteem accompanied by feelings of identity confusion, loss of confidence, heightened vulnerability, depression and growing feelings of shame and self-consciousness focused on physical appearance." It seems like many women are brainwashed by the restrictive societal images of what it means to be a woman. Older women may want to give their lives the meaning and value they cannot find in a society that refuses them. They search for workshops, a full-time study, or any other activity that makes them feel good, empowers them, helps them discover their own feminine subjectivity, and ultimately reinforces their identities as women.

Preoccupation with looking young might draw energy away from a woman's inner life and diminish her attention to other projects. Women spend immense amounts of money[8] on cosmetics, plastic surgery, and Botox treatments in order to look as young and as attractive as possible. They seek to have faces and bodies that are compatible to the mainstream image of a pretty woman so that they are seen, accepted, and liked in society. Becoming an "older woman" not only has implications on how a woman thinks about herself, but it also determines how others might behave. Many women in my workshops mention issues of invisibility. Sarah Pearlman confirms that women experience that "somewhere in the fifties there is an acceleration of social invisibility, inattention and rejection." Middle-aged women are rated as less attractive and are seen to have more undesirable characteristics than men of the same age. Finding a balance in how the outside

world (everything perceived in the world; everything seen and heard) influences the inner world (the perceived self, self-awareness, all that one experiences) is challenging for women in general because they are treated according to their "to-be-looked-at-ness", but it's specifically difficult for women after forty, when menopause is dawning and they are getting "old."

However, this is not only a burning issue for "older" women. Young women experience issues of self-awareness and identity as well. By being treated as the object of desire and pushed into identification with their bodies and appearance by the external gaze of society, young women who are in the process of establishing self-identity experience confusion. Many girls have difficulties asserting their own worth and maintaining emotional boundaries. In 2003, sociologist Anne Byrne did research on single women in Ireland. She describes the self-identity of women as the self-knowledge, care, and practices of the self (e.g., their choices) and the capacity to narrate the self (i.e., being self-reflective). The theme of self-identity as the self-experienced identity ("Who am I to myself?") in contrast to the social self that women strongly identify with (wife, mother, daughter) was a challenging subject for the single women in Byrne's study.[9] Also, for young women it is hard to resist oppressive societal expectations and establish a femininity that fits their own needs.

Psychologist and feminist Carol Gilligan wrote *In a Different Voice*,[10] a book on psychological theory and women's development in which women's voices were heard, in their own right and with their own integrity, for the first time in social scientific theorizing about women. In asking women, "How would you describe yourself?" Gilligan found that women define who they are by describing relationships. Men defined themselves by separation or the use of "I" statements. In listening carefully to how women talk, Gilligan discovered a difference between men's "ethics of justice" and women's "ethics of care." Artist and feminist Judy Chicago wrote in 2014,

> It is not a lack of talent, intelligence or ability that has prevented women from fully realizing their potential, it is a life structure that makes too many demands.[11]

Through their socialization, women are still conditioned to direct their major attention to the welfare of others and to focus on those realms of life that are concerned with building and sustaining relationships. Male socialization is directed toward individuation, autonomy, and personal achievement in the public arena.

Psychiatrist Carl Jung stated that individuation is achievable only through turning inward because it is built on fidelity to personal goals and meanings. Turning inward and discovering the personal inner world, the individual subjectivity, is absolutely mandatory to enhance the process of individuation. This process incorporates the development of a dialogue with ourselves, becoming separate from the

collective, developing an authentic self, and regrouping with the collective in a more authentic and real way. Individuation is a lifelong, constant process of finding oneself. Maybe that is why so many women seek activities that have to do with discovering or developing self-identity. Individuation for women is distorted because they have been socialized with a strong relational, caring-for-others focus.

Alistair McFadyen, an academic theologian at the University of Leeds, works mainly on the theme of humanity, trying to understand how to be human and what it means to be human in practice as well as in theory. He writes that women tend to be socialized in ways that decenter the orientation of their personal energies and dissipate them. Under the conditions of patriarchy, the nurturing self-giving and orientation on others expected of women easily turns pathological: women may acquire weak and fragmented selves by giving everything of themselves in relationships. They experience "disorientation in life-intentionality as the power to be a genuinely integrated self is dissipated." The problem of women is that they are constantly "at work," putting time and energy into one "insignificant" task after the other in order to maintain relationships and nurture and meet the needs of others. As they identify with their many social roles, they are responsible for very many tasks. It seems like women are constantly coordinating multiple timetables. Thus, they become so fully oriented away from themselves because all their energy is directed toward others, that they have no time for themselves. After the about twenty years of working, raising children, and caring about everybody around them, women may experience "self-loss." This hinders any real accomplishment on the part of many women, and it systematically prevents them from establishing a firm self-identity.[12]

One of my students formulated it as follows.

> But I think women in society have to do so very many things! An incredible load, maybe that's why I'm interested in women, I feel they are so loaded, they are mother, lover, wife, professional, child … she has to be responsible for the friends, and when is she a woman … I ask you? … I don't know."
> —Tina

According to McFadyen, women's life-intentionality may become so fully oriented away from themselves because all their energy is directed toward others, that they have to time left for themselves. With all personal energy directed externally, women easily become self-forgetful. It is not just that they may have little time or energy left to look after their own identity; it is rather that the identity of the self loses its own integrity and collapses into relationships of nurture, service, and care. All their energies of life-intentionality are thus orientated away from the self so that the energy to maintain one's integrity, to be for oneself and for others as oneself, is dissipated. For as soon as it is marshaled, it is spent elsewhere. It may never achieve sufficient concentration or duration in orientation on the self. Homemakers especially struggle for their sense of identity.

In her 1927 diary, de Beauvoir writes, "The conflict of self and other arises, in part, when the search for meaning conflicts with the search for love." According to de Beauvoir, all male ideologies are directed at justifying the oppression of women, and women are so conditioned by society that they consent to this oppression. American author, feminist, and social activist bell hooks[13] writes that oppressed individuals learn to adapt to the culture of domination in which they are immersed. They become inhibited from engaging in the struggle for freedom, truth, and justice; incapable of taking risks; and afraid of repression.

In 1986 psychologist Mary Belenky and her colleagues interviewed 135 women because they wanted to understand "what they knew about life and how they knew it." They found that women repeatedly used the metaphor of voice to depict their intellectual and ethical development. The authors created a taxonomy of "women's ways of knowing." Many of the women they describe listened to other voices (external authorities) for most of their lives, only to move into the subjectivist perspective of listening to their own voices at age forty or fifty, after years of raising children, managing households, or working outside the home. This basically happened after a major crisis of trust in male authority! The category where trust in a sense of self and voice was practically absent was called "Silence," and it was characterized by a total dependence on the standpoints of external authority, where the personal opinion was absent. Women in this category could hardly speak of self and were without a true voice, afraid that speaking out would only make them appear ignorant or bring negative repercussions. They saw authority as all-powerful and overbearing. In the last category, "Constructed Knowledge" (all knowledge is seen as contextual), women were able to listen, share, and cooperate while maintaining their own voices undiminished. The authors found that voice was a metaphor that could apply to many aspects of women's experience and development. This book shows that having a personal opinion, a personal voice, is not evident for all women. Reliance on self and emergence of voice happens when women start to realize that their own experiences may be of value—when they start to trust themselves.

One of my students felt insecure when I asked her what was still not clear to her concerning her artistic process.

> What is not clear to me, I don't know if this is the right answer, what is not clear is that I don't know if what I'm doing … if it says anything, if it is, how shall I say it, if it is worth anything. No not worth it is not the right word, if it is special in some ways. I don't know. As I have a strong judge inside me … That's why I doubt so much … I don't know if what I do is worth anything. I have become milder now but still I don't know if it is worth anything. If I would see my collages in an exhibition I

don't know if I would like them. But I wouldn't believe they were mine.
—Markella

Many workshops and webinars are offered to bring people back to their self, promising personal transformation, the realization of the full potential, help on the journey of self-discovery, or even "soul retrieval." The people who apply to participate are women for the most part. These are workshops that promise to give deepening of self-love, self-acceptance and self-esteem, the realization of self-worth, personal growth, and "finding the life purpose." All this has to do with identity. Why are so many women on a quest to find out who they are? Why do they have to learn to love themselves? Why are they so insecure? Why have some become self-forgetful? Women are longing to become empowered, develop a strong self-identity, establish themselves as subjects, take the power over their lives in their own hands, and use their voices as a reaction to the oppression they experience in the patriarchal society in which they are living.

So how can a woman
 - who has internalized the culture of domination in which she is socialized and has adapted to it,
 - who is busy for a great deal with her "to-be-looked-at-ness" and what other people think of her,
 - who feels she "looks old",
 - who feels she is invisible,
 - who doesn't dare to stand up for her own opinion and "use her voice" because she has
 - been silenced so many times,
 - who has, for the greatest part of her life, directed most of her energy toward others because she has lived a life of too many demands having to do with the care and development of others, having put time and energy into one insignificant task after the other in order to nurture and meet the needs of those others; and
 - who has, as a result, experienced loss of self-esteem, feelings of identity confusion, and maybe even self-loss,

develop a strong self-identity and move from listening to and obeying the external authorities—the "other" voices, the patriarchal social and cultural norms and ideologies—which she feels she cannot trust because they do not have her interest at heart? How can she make the shift, start to listen to her own internal authority, move into her own subjectivist perspective, and listen to her own voice in order to take back the power over her own life?

As women share a fundamental disposition toward relating to others and finding their central meaning in life through relationships, the experience of self for women sometimes feels like a wet bar of soap slipping out of their hands. Self-actualization is a process of becoming more aware of the self, it's the ability to make sense, to find meaning in life. The self is made out of accumulated past experience, memory, and

imagination, the inner world, the character, opinions about life, desires. How can a woman make that shift, and start to explore her own inner world, her self-desired self-image, and regain the self-esteem that is necessary to mobilize her other strengths and start a process of personal growth? How can she make that shift and start to discover those feelings, ideas, and concepts that are meaningful to her and feel right? How can she start that dialogue with herself?

Exploring the Self in Art

Becoming self-aware happens through self-reflective thinking. This generates the self and is the foundation for self and identity: the self comes into being through extensive self-reflection. It is very important to practice self-reflective thinking. The more you spend time alone, researching your own unique inner world, the more you realize this time alone helps you to center yourself. Centering yourself helps you discover your own terms and conditions for your life, and that you know very well who you are. A woman has to connect to her own story, to who she was, to who she is, and to what she always wanted for herself. This happens when she visualizes her own life experiences and finds ways to express these images and share them with others. Then she may get closer to her thinking self and her feeling self, and she may find her voice. The answer to the core questions "Who am I? What is important for me?" is in visualizing self-reflective thinking, visualizing thought processes. According to psychiatrist Carl Jung, the soul narrates its deepest truth through image and metaphor. The key to make this happen, the magic wand, is art making. And because this book is meant for every woman who wants to discover her artistic voice, even an absolute beginner, it uses collage art, which provides a vast richness of images and has an easy technique. That doesn't mean if you want to paint or write, you shouldn't use this book! The medium is your choice; the method works for every medium.

Practicing self-reflective thinking and visualization encourages women to formulate a reality for themselves where they can thrive instead of survive. It is a way for women to discover how to be the subjects in their own lives; how to become like the sun and produce their own light instead of being like the moon, reflecting the light coming from another source. Exploration of personal issues through making art functions as a mirror for women to discover their own individual identities, fighting stereotypes and identifications with stereotypes that are not in congruence with their own personalities. Analyzing and visualizing internalized oppression would be the way for women to find and validate their authentic selves and their own perspectives in life. Through the method "images behind words" used in this book, women can discover what images they see behind "woman," "me," or "my life." Art making can be an important tool for personal empowerment. Self-empowerment and finding one's own voice in life is a key way for true liberation from an oppressive patriarchal social system that excludes women's experiences and perspectives. That's why this book was written for women.

Experiences of Women in the Workshop

Oppression and lack of freedom was a common theme in the artwork and interviews of the three women presented in this book. In the discourse and artwork of all three participants of whom I recorded the artistic process, there was a strong presence of the feeling "me and the others." Markella had a strong male "internal judge" that didn't let her experiment and try ideas—until I told her she should put that judge in another room. Every time she was severely self-critical, I would say, "Did he escape? Can you please put him back?" She also had a very strong sense of the way other people would judge her work.

> I started off … lousy, I wasn't good. I felt really bad. My work was bad, I felt it, I understood, I couldn't express what I really wanted. And even now I don't know if the results are good. If an experienced collage artist would judge them I don't know if he would think they were worth anything … but at least I am able to express my feelings now.
> —Markella

Tina had a strong issue with freedom and with restraint.

> Remember the collage I made with the hands? That's what I wanted to say. I don't want you to restrict me. That gives me fear. That you take my freedom.
> —Tina

Anna, *Being in the Shadow of a Mentality*, photomontage

14 Annette Luycx

Tina used many eyes in her work, and she stitched some collages with string. In the exhibition, she had "tied" all her artwork with string. The artwork with the dishwashing glove was also tied with string. Markella also used the metaphor of being tied: a mermaid tied in rope.

Anna worked on the issue of "being in the shadow of a person or a mentality" and had difficulty with belonging and being accepted in other groups because she had her own ways. She used shadows in nearly all her artwork. She would cut out people from magazines and make them black with acrylic paint. Then she discovered Photoshop, and she scanned these shadows into her Photoshopped artwork consisting of collage and her own photographs.

Anna sensed the oppression she feels is the patriarchal society.

> And then I thought in the life I'm living many times I feel "under the shadow of something or somebody." It could be a person, it can be the mentality that dominates that is different from mine, and I have to take that all the time into account to do things. So in my collages this comes out as "in the shadow of some idea, some mentality, some movement" that doesn't match mine, that doesn't suit me. The mentality of the man, in the meaning of the patriarchal society. I feel that this still is very strong. And when I say that, people say, "What are you saying?" but I feel it. And this theme with the shadow, it suited me. I can and I start to express this "under the shadow" feeling slowly that I have now. Like there is something on top of me that puts my head down, it imprisons me a little. Because I feel it, I work on it, and I can express it.
> —Anna

I think it is obvious this theme came out as I encouraged the women in the workshop to choose issues for collage that had deep personal meaning, issues they felt passionate about. I encouraged them to explore which images they could see "behind" their words. Markella's issue was "Anger," Tina's issue was "Feelings of Women," and Anna's issue was "Under the Shadow." Tina initially wanted to work on the issue "Oppressed Women" but changed it after two weeks to "Feelings of Women." It burdened her too much to work on this; she said it was too heavy. But she made a beautiful small collage in her artist's journal on "Fear of Losing Freedom = Hands Holding Me" featuring a woman: her face is invisible, and she's being pushed down by a large hand on her head.

Tina, *Fear of Losing Freedom = Hands Holding Me*, photomontage

Two other students in the group also showed imagery of women's oppression in their collages. Apparently this theme is present so strongly in the inner worlds of these women that they wanted to give it expression in their artwork. It strongly has the imprint of the Mediterranean patriarchal society, which does not let women grow as individuals but reduces them to the roles they are allowed to play in this society: mothers, daughters, wives—only roles that exist in relation to someone else, not independently as individuals.

Visualizing thought processes produces images that support a struggle for growth and individuation. It seems that during and at the end of the workshop, the participants were just beginning to recognize the internal conflicts they were confronting between their desire to grow in more authentic ways and the circumstances that constrain their lives. As they were given a voice in visual language, participants found images related to this oppression and to resisting patriarchal constraints through focusing on personal metaphors, feelings, memories, dreams, and colors. The fact that the women in my book encountered personal images of oppression encapsulated in their narrative empowered them. By expressing them, they took control over them and became empowered.

After doing the interviews with the three women in this book, I shared the above reflections with them to check whether I wasn't seeing something I wanted to see. This is what they said.

I like your reflections very much, they really touch me. But I think the increased self-reflection was not so much due to your teaching strategies, but that making art itself produces self-reflection. I wanted to comment on what you wrote about the patriarchal society: "This theme strongly has the imprint of the Mediterranean patriarchal society, which does not let women grow as individuals but reduces them to the roles they are allowed to play in this society: mothers, daughters, wives—only roles that exist in relation to someone else, not independently as individuals." I don't mind having the roles of daughter, wife, mother. I want to relate, I want to have those roles, but in my own way so that I can integrate these roles inside me. I don't like the stereotype of the patriarchal society. I want to be a mother, but not when the father is not helping. The problem with the patriarchal society is that it imposes a model I don't like. The other thing I wanted to comment on is what you said about de Beauvoir: "He is the subject, she is the other." I recognize that very often, that I am an object of desire and not a subject. I have felt that very often, and it bothers me, and then I'm gone. So I am free but alone. The balance will be established when men will try to behave in a more respectful way. I am very pleased that you did this research on only women. It is very necessary.
—Anna

I agree with the interview, it was exactly what we said. I wanted to comment on what you said about the oppression of the patriarchal society. I don't feel suppressed by the patriarchal society. Now that the country is involved in an economical crisis, now I feel oppression by the system; others decide over us, it is so unjust. Hardworking people lose their jobs. I feel suppressed by that power outside me. I think that's why I used so many ropes in my work. I feel I'm free and strong, I always had a good job, and people respected me. They didn't suppress me. Maybe I'm not a good example because my parents were left wing, and they were equal; my father helped my mother in the house. I was free, and they let me go out with boys. No, I do not feel suppressed. The past two years I do, because I feel my freedom is being taken away.
—Markella

What you wrote about me is correct. I don't like it when people exert power over me and take away my freedom. And yes, I am suppressed by the patriarchal family. The family of my husband, they suppressed me enormously. The men, but also the women. And as I always say what I want to say, I am the black sheep of that family now. I felt it and did my revolution. Sometimes I gave in, but it bothered me. My family was fine. My father was strong, but he didn't suppress me. In my work, I feel much suppressed, and I have to work extremely hard to keep my job. They require the impossible from me. It is correct what you said about the oppression of the patriarchal society. The hands that I used in my artwork are hands that suffocate me or take me by the hand and lead me to something I don't want it. I don't want people to take me by the hand. Yes, I agree with your reflections; it is good that you said it. In our society, women are much suppressed. I agree with all you said.
—Tina

I think my workshops are so packed with women because art making is an ideal way for women to become aware of who they really are. It is a way of giving even the shiest and most inhibited woman back her voice. Art making empowers women because by bringing their stories and life experiences into the art-making process using their imagination, they recreate their personal identities. More than men, women seem to need to turn to themselves and use art as a means to practice a dialogue with the self and establish a strong self-identity, as women are socialized in a way that hinders their individuation, according to the "love-empathy mode."[14] Female socialization prepares women for relationships; male socialization means individuation, autonomy, and mastery. "Men already know more. Or *think* they do. No need to take classes."[15] By making art, women can connect to their life experiences, and by visualizing and expressing these, they develop not only their artistic ability but also their self-identity. Finding your own style in art and in life—that is the essence of developing artistic voice.

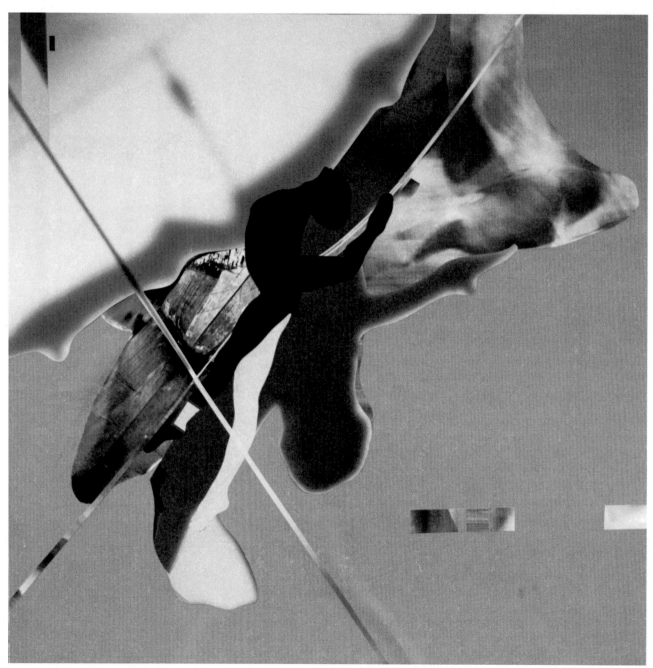

Tina, *Feeling Free*, photomontage

3. The Artist's Journal: Mining Inspiration from Your Inner World

How can you start a dialogue with yourself? How can you start to explore your own inner world and find interesting personal subject matter you could use for art making? The process of becoming self-aware happens through self-reflective thinking. Connecting to your personal story, your life narrative, happens when you remember and visualize your own life experiences, find ways to express these images, and share them with others. Visualizing self-reflective thinking, or visualizing thought processes, is the basis of art making. It is the cooperation of the cognitive mind with the imagination.

By keeping a diary or artist's journal, you can connect self-reflective thinking and writing with art making. It is a kind of visual brainstorming for ideas, keeping a diary with illustrations. An artist's journal is a notebook with blank pages, any size you like. In your artist's journal, you can write about everything that relates to an issue of personal interest you'd like to work on in your art making. Here, you can delve into the associations between words, images, and feelings. In your artist's journal, you can brainstorm freely, sketch, stick in images, or make small studies. You may try out ideas for collages or mixed-media artwork on a small scale. You are completely free to use your art journal the way you like it. Anything that is meaningful to you can be visualized in your art journal. It is a place to discover, try out, and explore your own ways, symbols, colors, metaphors, and more. It is a place where you can explore your memories and connect to your feelings. An artist's journal is also a research journal because you will have to go on a quest to find the answers to your questions, and you may embark on long journeys in the history of art or inside your own history of life experiences. You will discover the relation between inside yourself and outside yourself, understand you can fully relate to all the artists that you like, and realize that you and they share the same human experience. In searching for the right image for "Anger," for instance, Markella started with saying she saw angry wild animals, like tigers and leopards. But then she said, "No, my feeling of anger relates more to what a bull feels at a bullfight," and after doing research, she found the image that eventually fit perfectly: the horses and bulls from Picasso's painting *Guernica*. It is a white, black, and gray

painting of enormous proportions, 3.49 meters tall and 7.76 meters long. Picasso painted it after the bombing of Guernica, a small town in northern Spain, by fascist forces of Germany and Italy. Markella discovered that the painting expressed exactly how anger felt for her: anger that is aroused as a result of power and violence. She used two of the images to further explore in a new collage how to visually express what anger felt like for her. She discovered it felt like an explosion of an atom bomb, as well as string highly strung and ropes being tight.

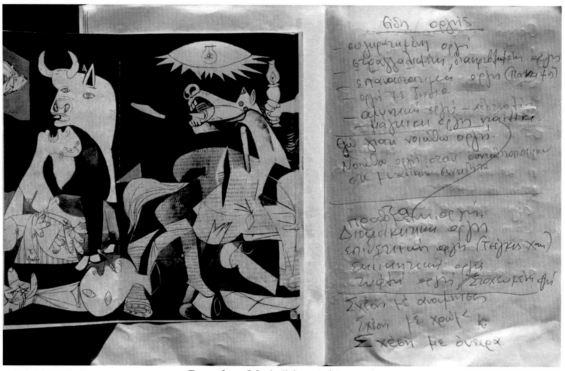

Pages from Markella's artist's journal.

Many famous artists are known for their art diaries; the sketchbooks of Leonardo da Vinci[16] are probably the best-known example. Other artists to have used art journals include Frida Kahlo.

Frida Kahlo's Art Diary

Frida Kahlo de Rivera (1907 – 1954) was a Mexican painter who mostly painted self-portraits. Inspired by Mexican popular culture, she employed a naïve folk art style to explore questions of identity, postcolonialism, gender, class, and race in Mexican society. Her paintings often had strong autobiographical elements and mixed realism with fantasy. Frida kept an art diary her whole life.[17]

Spanning 1944–1954, the final ten years of the artist's troubled lifetime, the diary is a captivating commonplace book filled with Kahlo's thoughts, poems, and dreams. Kahlo's prose delves into the associations between images and words, feelings and thought. Her brightly colored, rounded script is accompanied by watercolor illustrations that offer wonderful insight into her creative approach; the sketches and paintings were often reworked and incorporated into Kahlo's later works.

A number of themes recur throughout the journal in both text and imagery. These range from allusions to pre-Columbian Mexican culture (Aztec symbols and Nahuatl words) to communism, both of which were integral to Kahlo and her beliefs. Most striking of all, however, are the frequent references to her husband, Diego Rivera (to whom many of the pages are devoted in the form of passionate love letters and endless dedications), as well as to her ever-failing health (she suffered polio as a child and a body-breaking, near fatal accident at eighteen, which led to around thirty-five operations throughout her life). What is most interesting and moving about her diary in its published form is that it was never meant for public consumption; it was intended instead as a journal in time, a private record written by a woman for herself and about herself.[18]

> Anguish and pain, pleasure and death are no more than a process. —Frida Kahlo

Buy yourself a visual artist's journal to reflect on ideas, write, draw, and insert images. Using your artist's journal will help you play with ideas for collages, drawings, or mixed-media paintings. You will use your artist's journal every week for the exercises in the session. Feel free to use it any way you want. You will slowly realize that writing and making art are very connected because the words carry many images on their backs!

Your three classmates in the book show how different each student approached visualizing and writing as a method to get in touch with the self.

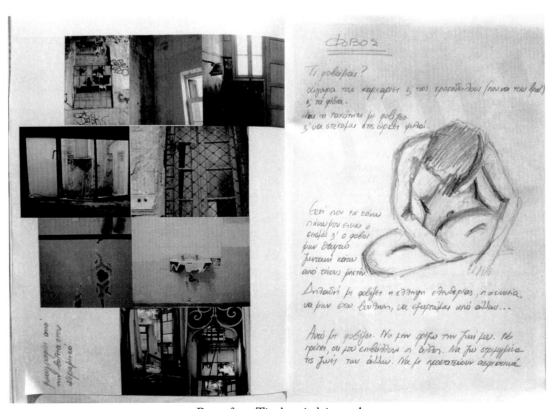

Pages from Tina's artist's journal

At the end of the workshop, Tina said about the artist's journal,

> I have to tell you about the artist's journal. It was a different way of working, it was a change in my way of working because it forced me to write things, and I don't write. It was sudden. It was beautiful. It was something new, and I should have mentioned it earlier. It was something new. It was beautiful. And I have never written in a diary. So imagine it was very strange to me. But I went close to it and I started to embrace it, and I started to make notes, and I put small things inside and small collages, and drafts of ideas. I liked it, it was beautiful.

"How did it help you?" I asked her.

> I made notes and I stuck things, and small collages, and small syntheses. And I liked the small size was fun. The bigger size of a real collage exposes you, but with the small size in the journal, you don't care, nobody sees it, it's yours. It was fun. It brought me closer to my issue and made me feel free. I made something in the journal, and it was like I started something. It was fun; I liked it. It brought me closer to the issue I was working on.

Here's a translation of Tina's text on "Fear" in her artist's journal.

> Fear. What am I afraid of? Definitely sharks and crocodiles (although you cannot find them here!) and snakes. And speed frightens me. And standing on my toes. The thing that frightens me most is an earthquake, and the fear that I might be buried alive under tons of concrete. I'm afraid of not being free, immobility, not to have free will, to be dependent on others. That frightens me. That I am not able to define my life. That I have to do what others impose on me. To live squeezed in the lives of others. That they "protect" me while they are suffocating me.

Markella mentioned the following.

> I used my artist's journal to gather images, and I wrote some things, in the beginning, when I was thinking about my issue. I wrote some short sentences

that analyzed the issue, and they gave me ideas for collages. Subthemes. I had "anger," so I wrote revolutionary anger, feminist anger, social anger, restrained anger, assertive anger, blind anger … and that would give me ideas. And through the words, I got ideas for collages. I would look at the journal, and I would get ideas for collages. And now if I want to get ideas, I open the journal and look at what I've written. Or if I remember something, I note it down, or I write down feelings that have to do with my issue. It helped me a lot. And because I don't have so much time, I didn't use it the way I wanted to have used it. But still it helped me.

Anna never used the artist's journal as such, but she used the idea of the journal in her mind! I asked her, "How did you use the artist's journal? How did it help you?"

Well, in the artist's journal I have only written three words! But it exists in my mind. I think of my journal. I think that I have a journal, and I could write in it about what I have done, about what I want to do. About what I feel. But I don't do it. The image comes because I process everything in my mind like I could do in the journal. I don't write because I want everything I think to make an image. And because I have to write a lot for my seminars and my talks, in your session I do a "click," and I see color, and I don't write because I am afraid that if I write, I will read and write. But the journal, I have it.

Making a photomontage

4. How to Make a Collage

Preferably in a specific room or corner of your house (if you don't have an extra room), you need a relatively large table to work on. You also need the following.

- an art journal as big as you like, with white pages
- a great variety of magazines
- scissors
- glue (a glue stick for cut and pasted images from magazines, PVA glue for mixed media)
- cutters and a cutting board
- a metal ruler
- colored paper
- twelve three-ounce acrylic paints of various colors
- a few brushes
- a laptop and inkjet printer are optional (to find and print images from the Internet)
- cardboard, paper, or stretched canvas to work on
- some space to store your artwork (a drawer or storeroom); this space should be dry!

Collage is the overall term for everything you can stick on whatever surface you like. It comes from the French verb *coller*, which means "to stick, to glue." Collage has many possibilities: photomontage of cut-and-pasted photographs (from magazines or made by yourself), compositions with colored paper, newspaper, and found papers, and a combination of all these. Collage art started to appear in modern art at the beginnings of the twentieth century, in Paris. In 1912 artists Pablo Picasso and Georges Braque were searching for ways to depict three-dimensionality in their cubist paintings. They experimented with *papiers collés*: they glued pieces of newspaper, wallpaper, and plain colored paper on their paintings. At the same time in Berlin, artists Hannah Höch, Raoul Hausmann and John Heartfield invented photomontage by cutting up pictures from magazines and reassembling them into new compositions. Collage art was also the ideal means of expression for the surrealist artists in Paris. This art movement started officially in 1924 with the publication of *Surrealist Manifesto* by writer André Breton. Inspired by Freud's theory of the subconscious, the surrealist artists used the technique of free association to express their fantasies and dreams in paintings and collages using parts of photographs from magazines, old engravings, drawings, and a great diversity of papers. Joan Miro even used cardboard and sandpaper. During World War II, Henri Matisse discovered how to "draw with scissors," and he invented his now very famous colored paper collages, made out of sheets of paper that he and his assistants

painted by hand in his favorite colors. American artist Romare Bearden liked this idea and made his own painted papers, which he cut into tiny pieces in order to use them to build his collaged compositions. He also used pieces of photographs (faces, eyes, hands, etc.) in his artwork. Abstract expressionist artist Lee Krasner was also inspired by the colored shapes of Matisse and his bold use of white and black together with color. She made collages from the pieces of her own cut-up paintings and sketches, and occasionally she cut up a painting of her husband Jackson Pollock and used those pieces as well. Look on the Internet for her works *Bald Eagle* from 1955 (oil paint, paper, and canvas on linen) or *Milkweed* from 1955 (oil paint, paper, and canvas collage on canvas). British photomontage artist John Stezaker cuts up portraits of men and women and creates new, compelling characters. He splices and overlaps famous faces, creating hybrid icons that dissociate the familiar. He is inspired by the original work of Hannah Höch and the surrealist concept of free association.

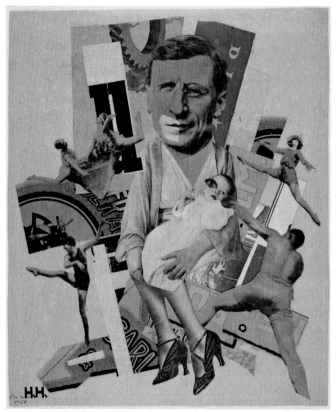

Hannah Höch, *The Father*, 1920, photomontage

The Internet is the ideal place to research collage and photomontage artists and discover your favorite ones. You learn a lot by analyzing their works and getting ideas from them. The book *Collage: The Making of Modern Art* by Brandon Taylor[19] gives a profound overview of the developments in collage.

Collage art isn't so difficult. There are no specific guidelines of how to make a collage; this is completely left to the choices of the artist. In collage you may work with a classical composition, using perspective and making it very realistic, or you may follow the more dadaist[20] or surrealist[21] ways, which means you stick anything together just the way you like it, inspired by your feelings or imagination. Even people who have never made any art love collage because it is so liberating: everything is possible. The basic thought behind a collage is the

concept of layering. There is a background that might be a photograph, a combination of photographs, or a sheet of colored paper. You might also start with black or white cardboard, as my students in this book did. Then you add your images. You can place one in front of the other, or one next to the other. By moving them around and playing with them, you will find the right position for each image. The decisive factor is that it feels good and you like it. The composition creates itself by self-reflective questioning. For Markella, anger was like an animal. Which animal? A bull. She also discovered anger was like a nuclear explosion. Anger was like the power in nature: a storm at sea with big waves. Anger was also violence—the violence of weapons. She played with words in her artist journal and found *revolutionary anger, feminist anger, social anger, restrained anger, assertive anger, blind anger.* Those words gave her images for her collages.

In each session of this workshop you will make your own personal composition of the images you find in your imagination with the help of the introductory talk and the exercises. Experimentation is key. Finding your own solutions to your art-making challenges is one of the fun sides of making art. If you doubt about the execution of your artwork, make small studies in your artist's journal so you can explore the possibilities. You will experience that this kind of personal art expresses how you feel, and it gives you the possibility to find your personal images in your imagination with the help of words you use in your narrative. It will facilitate you to first write about the issue you are interested in, visualize the words you used in your imagination, and then search for the images in magazines or on the Internet.

If you intend to sell your work or publish some of it in a book, you have to keep in mind that you might have used photographs that are protected by copyright. The copyright is held either by the creator (photographer/artist) or the publisher if the creator signed over rights to that publisher (this may be the case with works produced for a magazine or newspaper). You could either trace the photographer and ask for permission, or you may decide to find copyright-free images. There are at least a dozen sites on the Internet that offer copyright-free images. Still, many artists take the risk and make photomontages with "appropriated images" because they claim they transform them into new works of art. They claim they use "found images" and "recycle" them, putting them in a new context. They have exhibitions in galleries and museums. *Appropriation* is a new term in art, but it is a misty field. In theory, even if you take a small piece of a photograph, there might be a problem with copyright unless it falls under fair use. "Fair use is a copyright principle based on the belief that the public is entitled to freely use portions of copyrighted materials for purposes of commentary and criticism."[22] It is up to you to decide what you think of this and how you want to work with images you find in newspapers and magazines.

Please have a look at this photomontage that I made with my own photos. My central idea was "relations between people." A few years ago, I made a series of works called "Coexistence and Conflict." Led by my passion for theatre and the human soul, I used photomontage to "stage" unresolved narratives of fear, alienation, irresolute desire, and tension between people (and occasionally within one person). I found the idea of the film still, the image you see when you pause a film, very attractive. There is always an awkwardness and tension in such a film still, and you don't know how the scene will develop unless you press the play button. In my film stills, the environment of my characters functions as the "narrative of the space," a psychological metaphor of alienation, strangeness,

and fear. For inspiration, I looked at films by Hitchcock and Bergman, and I read books by Dostoyevsky and Ibsen. I became intrigued by people who are not mainstream or proper but are different, ungrounded, strange, or in a specific emotional state that is not clear. Here is one of those film stills, and the pictures I used for it. It is an example of how to layer and combine pictures in photomontage. As you can see, I followed certain "lines" in the photos with the scissors, to dissect the part I liked from the rest of the picture. I cut and pasted the different parts by hand.

Annette Luycx, *Easter Celebration Visitors in Greece*, photo.

Annette Luycx, *Under the Jones Falls Expressway Overpass in Baltimore #2*, photo.

Annette Luycx, *Under the Jones Falls Expressway Overpass in Baltimore #3*, photo.

Annette Luycx, *Under the Jones Falls Expressway Overpass in Baltimore #1*, photo.

Annette Luycx, *Baltimore Farmers' Market* and Bazaar, photo.

Annette Luycx, *Fourth of July*, photomontage.

Developing Artistic Voice

5. Your Twelve-Week Workshop

This workshop will provide you with the tools to explore and express the personal story you want to visually tell in your own way. In this art workbook, you will learn how to explore your inner world, the ways you experience life, and how to give expression to your story, your feelings, and your beliefs about life in visual art. During this workshop, you will be immersed into a deep process of communicating with the self and acquiring self-knowledge through artistic expression, because you will work with an issue of personal interest. This could be an issue you feel passionate about, an issue that makes your heart beat faster, or maybe a verb or a quality of life, like an emotion. For instance, women in my workshops have worked on "Blooming," "Nurturing," "Freedom," "Fear for the Empty Nest," "Anger," "Addiction," "Feelings of Women," "Being under the Shadow," and "Getting Old." The assignments offered to you each session, will encourage you to recall images from memories, feelings, and dreams and to find personal metaphors. They will lead you to research different sides of yourself.

You can travel around in your inner world, the world of your thoughts and imagination, by surfing on your own "Inner-Net". How does that work? Well, it works just like the regular Internet, but you have to work from your imagination! By imagining that you write a specific word (or maybe a sentence) on your "personal Google bar" (on the imaginary screen that is linked with your imagination) and pressing Enter, you will be able to enter your imagination, the library of your personal images. Imagine you type in your personal Google bar "school." After pressing Enter, everything you know and remember about school appears in front of your inner eye, and you "see" all the images about school you can imagine in your imagination: what a school is, what kinds of schools you know of, where you went to school, memories of being in school, people who were with you in school, and more. By using this unique technique to unlock your imagination, you can discover your personal world of images and their related feelings, memories, dreams, metaphors, and colors. You will realize how precious, rich, and valuable your own life experiences are as material for inspired personal works of art, made with your own ideas and images. You will go through the process of becoming an artist like real artists do and enjoy discovering and expressing who you are and what you want to say in your own way.

Except for your own life experiences, you need the tools and skills to use these life experiences as inspiration to become an artist. That is what this workshop will be about. It will teach you in a practical and revealing way all you need to know about the artistic process. You will develop artistic skill and visual ability, which includes the development of the inner eye, the imagination. You will learn how to tap into your personal artistic sources using visualization and imagination techniques, which will increase your artistic and visual sensitivity. Working with collage, mixed media, and paint gives this workshop the possibility to visualize your own narrative in a free and exploratory way. You will learn how to use your own life experiences as sources of inspired art making and to distill from these your own images and personal symbols. The focus will be on the artistic process, not on the end result. Specific exercises will help you to use your imagination and help you visualize the story you want to tell.

In this art workbook you will get to know a method based on the activation of this most important aspect of art making: the imagination. Because imagination blends thinking, feeling, and fantasizing, this method is called "Visualizing Words." Inspired by the Socratic method of establishing a dialogue with oneself based on questions, each session of the workshop starts by asking yourself questions. Imagine the issue of personal interest you feel passionate about is "Feelings of Women." By asking yourself questions, you start writing. Tina wrote the following in her artist journal.

> For me, the metaphor for my issue "Feelings of Women" is the sea. Images I
> see are: calm, beauty, vastness, serenity, storm, lightning, anger, danger, fear,
> always something new, wealth on the bottom of the sea, the waves playing
> with the air, playing with the sun. The color for "Feelings of Women" is red.
> I would never choose that color for a blouse … but for me it is tightly tied to
> woman. It is blood, life, birth. It is the heart. It is passion, affection, and love.
> It is pain and screams. It is fear and death.

From Talking to Imagining

When you are with your friends, you probably talk about yourself, your life, and your feelings. One step further would be to concentrate on the images you see behind the words you use to tell your story. For instance, have you ever asked yourself, "If I want to be an artist, what image do I see in my imagination? What kind of artist am I? Where am I working? What do I make?" You need to be self-reflective and ask yourself many questions in order to enter your personal imaginary Wonderland and become acquainted with visualization. For instance, if you think "empty nest," which images do you see? What do you feel about these images? By asking yourself many questions, you can go deeper into your personal experience of a specific word. "Freedom for me is a bird flying," said one student.

I asked, "What kind of bird? Where is it? What is it doing?"

She then described a seagull flying high above the sea, the sun reflecting on the waves. She said the seagull was using the wind to fly and didn't get tired flapping its wings. It was far away from the city, near a coastline with dunes. She paused for a second and then added, "I guess being free implies being alone, but it's a happy feeling."

Linking writing about a personal issue that interests you with visualization happens in session one. In subsequent sessions, you will explore your personal issue by finding images having to do with metaphors, exploring your memories, feelings, colors, dreams or nightmares, and your spirituality. By constantly going deeper into your imagination and practicing thinking words and seeing images by using your personal Inner-Net to enter your imagination, your art making will develop and your artistic voice will come to life. Visualizing what you think, what you imagine, and what you feel without the need to have a discussion about the why is a fantastic way to start an exploration of the self, to become conscious of the value of subjective experiences, and to discover personal artistic voice. In order to facilitate this personal process, it would help to work as much as possible in your visual art journal and use those white pages to reflect on ideas, write, draw, and insert images. Using your visual art journal will help you to play with ideas for your collages.

You will discover a lot of fun things during this workshop. We will look at a love poem and analyze the metaphors, their meaning, and the beauty of the image the poem creates. This will help you to go on a quest for the metaphorical images that could possibly express aspects of the issue of personal interest on which you are working. Color is an excellent way to incite you to connect you to your feelings. Emotion is an important driving force in making art. You will see that imagining and describing feelings behind each color will also produce exciting answers. For instance, orange made my students mention peacefulness ("It makes me think of Buddhist monks") and warm safeness ("the sunset in summer").

> Before doing this workshop, I worked ... spending my time creatively. Before I found some nice images and I put them together, there was no connection with my feeling. Like creative play. Maybe it was pretty, but it didn't mean anything. Now I feel it more.
> —Markella

Another session that will liberate your imagination deals with the exploration of images associated with memories. After reading an excerpt from the memoirs of a well-known writer, you will focus on the images that you see when hearing the text. Next, you will go on a personal quest for the images, colors, and metaphors you recall from your own memory in relation to your issue of personal interest, and you can explore this material in a new artwork. In the remaining sessions, you will explore the images of dreams

and nightmares, spirituality and personal symbols, the visual language of materials, and the language of abstract art and mixed media, all having to do with your personal issue. All of these assignments could be named Inner World–Activating Assignments because they will encourage you to dive deep inside yourself; zoom into your memories, dreams, feelings, cultural background, and beliefs; explore color and personal metaphors; and distill images from these areas of your mind.

I suggest you work once a week for twelve weeks; each session should last about two to three hours. You could also set aside twelve days and do one session a day! You should strive not to make works of art but to make visible the explorations and investigations on a certain issue of personal interest, because the workshop is about your artistic process, a process of visual discovery. You have to try to leave your verbal reality and enter the magic of your imagination. You should research all the possible images you can "see" behind the words you use, implementing visualization in order to describe the issue of personal interest about which you feel passionate. I use the word *passionate* on purpose because a strong emotion leads you to what you really care about, and it will provide you with powerful personal images. Try to push further and further into your personal world of images by asking questions.

The sequence of sessions includes the following art activities to liberate the imagination and explore the inner world.

1. The exploration of images behind words
2. Metaphors and the meaning of images: working with poems
3. Images from memories and memoires
4. Images behind color and the color of your personal issue
5. Images of dreams and nightmares: dreams at night and our dreams for the future
6. Images behind feelings, combining previous sessions with the idea of feelings
7. Spirituality and personal symbols connected to spirituality
8. The visual language of working in three dimensions with new materials
9. Abstract Art: exploring the abstract expression of your personal issue
10. Expressing your issue in mixed media
11. Choosing which session was most appealing or experimenting with a new idea
12. Preparing your exhibition

Every session of the workshop starts with an informative presentation of the theme of the week and a few easy and fun exercises. Take as much time as you need for the exercises. Then you will work with found images and photographs from magazines (or your own photographs), colored paper, paint, scissors, scalpels, glue, and other materials needed for the assignment of the week. You should investigate your issue from the perspective of the specific session. If you cannot finish your assignment in two hours, you have the whole week to work on it!

In each session, you will be introduced to a woman artist whose work matches the subject of the week. Have a look at her work on the Internet. Try to understand the link between her narrative, her imagination and her work. It is very interesting to see how different these eleven women are and to comprehend how their lives, their cultures, and the moments in history in which they lived expressed themselves in the subject matter and medium they used.

At the end of the workshop, you will organize an exhibition of your artwork for your family and friends at your house or at a friend's house. The final artworks will reflect this twelve-week journey to your inner world in your own personal way. You will enjoy sharing your artwork with your circle, and you will learn much from all the feedback you will get.

Give yourself the opportunity, time, space, and freedom to develop in your own way. Prompts are proposed and explained at the beginning of the session, but if you decide to do something else, that's fine. New learning starts at the point where you stopped the last time you learned. It happens suddenly when you are ready for it. For Anna, this moment happened in the eleventh week, when the course was nearly finished. I wrote about it in my diary.

> And Anna made such an interesting shape, stuck on other pieces of paper, added paint. Then when she realized she did something new and wonderful, she started thinking about it, and then she stopped! But she did the breakthrough, and although she always sits down and cuts something and finishes it at home, this time she was standing up the whole time. I was so surprised!

The soul of the adult learner is a free spirit that sings, "I'll do it my way!" During this workshop, there should not be any expectation at all. For instance, Tina liked to think about the assignments over the week and worked at home; during the workshop, she often worked on the assignment of the previous week. She wanted to be left alone and never asked me any questions. Here's one of my observations during the session on dreams.

> She carried a big bag with red cellophane and enlarged photocopies of the human heart. She loved the session on color and said, "This is my thing. I will work with the big red heart, the cellophane, and a face of a woman." She had worked on her idea the whole week and was very enthusiastic. She got inspired by the session on color, decided to explore the color red, found the heart and the bright red cellophane (she said to me during the session, "Red is the color

of women for me, the color of blood"), and knew/felt what she was going to do this session.

The session on color had been the previous week. The next week, when I presented "Feelings" as a source of inspiration, Tina worked on "Dreams."

> Tina was all happy and came in with a big sheet of a kind of foam and a lot of cutouts, all ready to be stuck on the big sheet. She had done all this work at home and at her office during her breaks. It was work done for the session on dreams of the previous week. She was very enthusiastic about the idea of making a collage on her theme "Feelings of Women" as a dream.

Anna mentioned during the interview how much she had appreciated this kind of mentoring in the workshop.

> I wanted to say to you, and maybe it has a relation now, that before I did sessions with you, I followed other sessions with other teachers that had a certain way of working. Because I did my own thing, the class threw me out. They didn't throw me out like "Get up and leave," but they said, "What are you doing? What is this? That is not art!" And I left. I was scolding and scolding. And I left. I couldn't coexist with the others. I feel much redeemed that you allow me, that I am in the class with the other students, and you let me do my own thing. And that I progress and that I learn.

As the workshop progresses, you will see how unique your three classmates are and that each one has her own distinctive "psycho synthesis." I realized I could propose something—an assignment, a direction, a subject, a way of working—but then I had to step aside and let the magic happen. The same counts for you. Be gentle with yourself. Take your time if it doesn't work the first time. Try again. Try in a different way. Explore and experiment. You are unique and perfect just the way you are. Listen to yourself and discover your own rhythm and pace of working. Enter your inner world, allowing yourself to approach remembering, feeling, visualizing, and expressing your life experiences in your own personal way, without judgment. There is no good art or bad art. There is only unique personal expression, which can be developed further through increased sensitization and going deeper into one's soul, asking many questions and looking for images, colors, contrasts, shadows and light,

personal metaphors, and personal symbols. This is surfing on the Inner-Net, writing words in your personal Google bar, and seeing where your inner web brings you. In this workshop, your goal is to visualize thoughts, words, feelings, memories, dreams, and intuitions, and to express personal life experience. There is never question of interpretation or psychological explanation. "Is it good?" is not the right question. You should ask yourself, "Do I like it? Does it feel right?"

Session 1
Images Behind Words: Accessing the Imagination

Art is a visual language. The discovery of your own style in art involves learning this visual language to give expression to your identity, your feelings, and your beliefs about life in images. But how do you learn to speak it? Where do you find images? These are stored in your imagination. Our imagination is like a library of images. You can enter the library of your imagination through your words! By visualizing images behind the words you use or said—in other words, by visualizing your narrative—you can access your imagination.

I call this surfing on the Inner-Net. You can imagine that searching for an image behind a word you use could be something like having a Google bar on the laptop of your imagination. Instead of using the Internet, you will use your Inner-Net. Type a word in your personal Google bar and press Enter, and lots of your own ideas, images, feelings, memories, and metaphors pop up. By using your Inner-Net, you can enter your inner world, your own private inner space of perception and imagination. Your imagination is the space of visualized thoughts. It is very important to practice self-reflective thinking. Be original! Search in your imagination till you have found your own images. Do not use the clichés in advertisements. This needs practice, but you'll get there!

In this workshop, you will learn how to visualize thoughts, words, feelings, memories, dreams, and intuitions, and you'll learn to use these as the source for your art making. You can play fun games with your imagination. You can see everything in your imagination like it happens in reality. A good example is daydreaming, where you imagine you are somewhere else doing fun things. By finding images and imaginary videos, you would be able to create your own imaginary film. Anything works! Maybe you are an astronaut traveling to Venus, or you are the owner of a restaurant in Paris, or you have taken a year off to travel around the world and have just arrived in Shanghai. In your imagination, you can choose a country to live in, create your dream house, and work your dream job. In short, you can visualize absolutely everything!

Write in your artist's journal as much as possible to practice the thinking, visualizing, and writing that is so important as a prevision for artistic explorations. Use your own life experiences as sources of inspired art making. Distill from these your own images and personal symbols through visualizing images behind words.

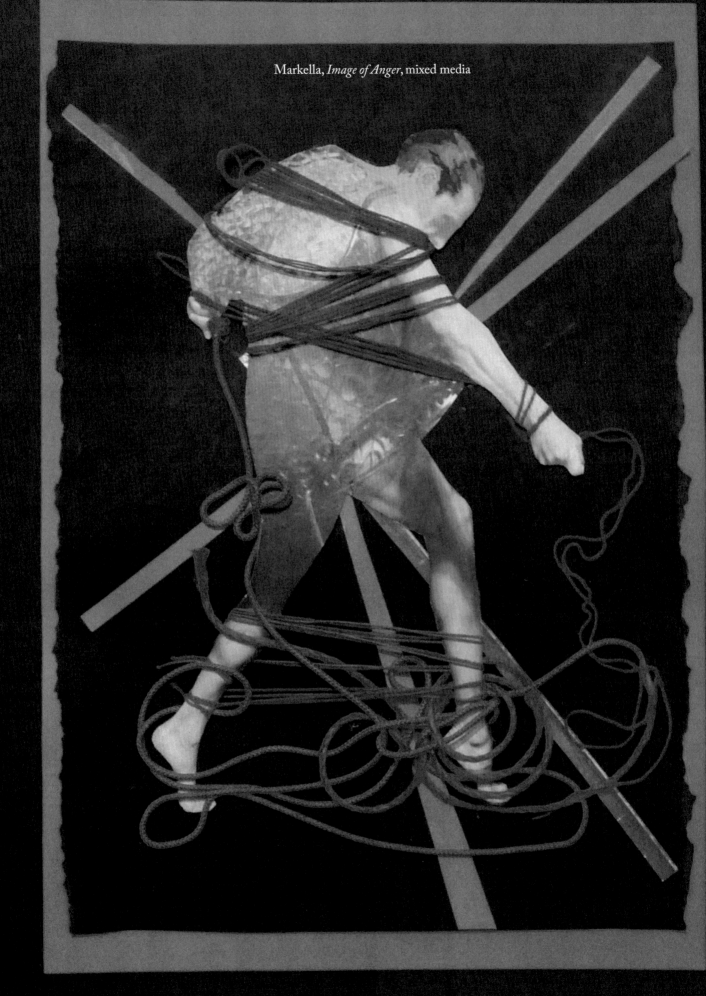

Markella, *Image of Anger*, mixed media

How can you visualize thoughts, feelings, or the story you want to tell? You can do that by asking yourself questions, writing down the answers, and then asking more questions. This process of asking questions in order to see is called the Socratic method. The oldest and still the most powerful teaching tactic for fostering reflective critical thinking is Socratic teaching. In Socratic teaching, the focus is on giving students questions, not answers. Socratic art education would be, "What do you know about art? What is your favorite artistic period in the history of art, and why? What do you know about painting? Who is your favorite artist, and why?" A Socratic teacher models inquiring minds by continually asking questions about a certain subject. You can apply this to yourself as well. After all, art making is a form of self-directed learning; you learn by doing what you invent or think of.

Exercise 1

To illustrate how visualizing images behind words works, think about the following prompt: "Describe in images the road from your house to another place. Imagine going to your work, a shop, the school of your kids, or the city center. Imagine your eyes were connected to a camera. What would it record?" At first you might say, "Roads and houses." Try to go a bit further. Okay, you've just locked your front door, and you've started walking or driving. What do you see? It is important to ask questions and more questions, just like Socrates. What is the road like? The people, the buildings, heaven—which colors do they have, what is the light like, and what catches your attention? Mention as many details as possible. One student said, "The sun set and the sky was purple," and she remembered looking at the neck of a guy in the car in front of her at the traffic lights. She had looked at some dark cafes with sunscreens rolled down, and she had thought that those cafes were so claustrophobic. Take five minutes to think about it and describe these images. Writing helps a lot for making art because thoughts are so ethereal: they often vanish instantly and make place for the next. When you write them down, together they start to create a visual reality. From the written-down images, it is an easy step to materializing the images into an artwork. Artistic thinking is thinking in images. It is the development of the visual brain.

Exercise 2

Let's try another exercise. Reflect on the word *tree*. Type it in the Google bar of your Inner-Net. Which image pops up? What kind of tree do you see in your imagination? Where does it grow, and in which season does it find itself? You have to ask yourself questions in order to see details. What kind of tree? How big is it? Where is it? Is it summer or winter? Is it day or night? Are there any birds in the tree? What about nests, panthers, owls, blossoms, nuts, or apples? Are there any ants running on its bark? Have any branches broken off? This is a method to sensitize your visual inner eye. Asking questions and practicing reflective thinking will help you to find your own images—no generalized images, no clichés. Here is the key for every artist to find her

own personal artistic expression, and ultimately her own artistic style. Now, try a more abstract word like time, power, or happiness. Freely browse your imagination, writing down all the images in your artist's journal.

Simply enjoying the imagination, freely associating, picking out images, or concentrating on staged compositions is very liberating, and that is the highway back to what life really feels like for you. Opening the door to the imagination is also giving you entrance to another very important aspect of art making: inspiration. Once inspiration has gotten hold of you, you will feel like you're in love. You will experience a state of focused attention and will only want to work on your art project!

Assignment

The point of departure of the workshop is to encourage you to find an issue of personal interest about which you feel passionate. Start with thinking about your life and what is meaningful to you. Write down the core questions "Who am I? What is important for me?" in your artist's journal. Then write a few paragraphs answering these questions. Look at your words, and underline the words that make your heart beat faster. They could be verbs or nouns. Choose the most important word. Then you will start to explore the images you see behind that word, like the way you did with the words *tree* and *time*. These images will be the basis for your first artwork. If that is hard, you can also start with which words pop up in your mind without thinking. Look at these words and choose one. Explore the images you see behind that word. Take your art journal and start describing your chosen personal issue. Then pause and look at the words. Every word reveals an image if you try. Ask many questions, like you did in the previous exercise. If your issue is the empty nest, for instance, ask yourself questions. "What is it like? What does it feel like? What does it make me think of?" Through questions, you will get a lot of information from yourself—and a lot of images. Make a nice cup of tea or coffee, sit behind your art table with a few old magazines, and start looking for pictures of the images you found. Cut out pictures of the images you saw behind the words you found that are related to your issue. If you cannot find what you are looking for, search on the real Internet. You might be looking for a hot air balloon. Type in your word and click on "Images." You might find the image that fits perfectly. Print out this image and cut it in such a way that you can use it in your collage. Combine your images in order to make a composition. As a background, you might use ordinary paper or preferably cardboard. Maybe using a glue stick is the easy way; if your cutout pictures are very large, then thinly applied acrylic medium or white glue (PVA) is a better solution.

You can do these exercises and the assignment on your own, or you can do them interactively with a few friends. It will help you to realize how different and diverse we all are, and how personal our way of perception really is. Through these exercises, you will start to realize the workings of art making. You have to think first and then investigate, ask questions, see images in your imagination, think about the execution of your artwork (size, composition), and start to explore! Thinking and imagination have to work together like a good span of horses to make the coach of artistic creation go smoothly and swiftly.

In this first session, you will experience that it is difficult to get started with an idea for an artwork. It will be challenging for you to generate images that have to do with your chosen issue. You should try to get out of your verbal reality and into the magic of your imagination, and you should research all the possible images you can see behind the words you use. Concentrate on play and exploration and see this workshop as an investigation of a personal issue or a meaningful life experience, as the first steps on the long road to developing artistic voice. Even well-established artists are constantly renewing themselves and searching for deeper and more elaborate ways of expressing themselves. This is a process that never stops. There are three important pillars in artistic development you should keep in mind: imaginative thinking (thinking in images), critical self-reflection (developing a dialogue with yourself), and self-directed learning (finding your own personal ways to experiment, to solve your personal art problems, and to learn by doing). It is very useful when you finish your artwork to do some evaluation of your process and ask yourself, "Where did I start? What did I discover? Where did I get stuck, and how did I solve it?"

Annette's Journal

First session. I created a large table by uniting three long, narrow tables into a table the size of a ping-pong table. The space is huge and high, and our voices bounce back. Everybody is happy to start again. Nobody has made a collage since May, when we met for the last time. We are seven.

I handed out a sheet of paper with the title of the course: "Becoming an Artist: Art as a Process." It explained that, contrary to previous sessions that centered on showing slides of other artists' work, this course will center on how students can generate and identify issues that are important in their lives, as well as select from these issues one they want to explore in a series of collages. I told the students that in every session, we will use prompts and exercises that stimulate the imagination. I explained to them that issues require self-reflection and investigation. The whole idea of artistic expression is to express who you are and what you think about the issue you are visually exploring. Issues also assume that conflict is involved, because it is easier to identify and explore an issue if one relates emotionally to a conflicting reality. I gave the example that somebody might choose as an issue "world peace," but how can you work with it if you don't include the dialectics between war and peace? I also told them that an issue could be personal like "personal freedom" or social like "illegal immigrants in Athens," who are hiding all the time and are not free; then they could think about how that issue relates to them.

> Yes, already from the first session, you unlocked me when you said, "Write down a few words that pop up in your mind right now, without thinking." And I wrote down *shadow*, *water*, and some others I don't remember. And it was like a window opened, because I immediately got in touch with myself,

through the words that popped up in my mind, through your question; that was the incentive. It was like a window opened.

—Anna

Anna, *Images of the Shadow*, photo-shopped photomontage

For Anna, a world opened because her theme was "Under the Shadow," which is a mysterious theme. In researching "What is behind the shadow?" she discovered a large world of personal experience that gave her material for her art. She also discovered how the shadow interacted with its environment.

Markella discovered that red was the color of anger, her personal issue, and the shape of anger was a triangle. After two sessions, she discovered that a dagger was her metaphor for anger. She found the image inspired by the pointy triangle.

When I started this workshop, my mind was very organized. And I couldn't disconnect from this organization of my brain and to function spontaneous,

instinctual, and without self-control, so to say. But slowly I started to philosophically and logically change the way I understood my issue and expressed it. My most serious difficulty was not to think too much, and also express what I think freely and instinctually…. You said we shouldn't think logically, but in terms of "shapes and colors." That really impressed me. That worked for me. Shapes and colors, you told me, and that turned the key for me. Without working on it in a logical way. Without logic, instinctual.
—Markella

Artist Related to This Session: Hannah Höch (1889–1978)

Hannah Höch[23] was born in 1889 in Germany into an upper-middle-class family. She was the oldest of five children. When she was twenty-three, she left home to study design and graphic arts at the craft-oriented School of Applied Arts in Berlin. She couldn't go right after high school at eighteen because when she was fifteen, her youngest sister was born, and her mother decided Hannah should look after her till she was six. Hannah originally wanted to go to the Berlin School of the Arts but didn't dare to tell her father, because going to an art school wasn't proper for girls at the time. About being in Berlin at the time of the First World War (1914–1918), she said,

Just as I was emerging from the dreamy years of my youth and becoming ardently involved with my studies, this catastrophe shattered my world. Surveying the consequences for humanity and for myself, I suffered greatly under my world's violent collapse.[24]

After her studies, she worked as a pattern designer for women's magazines. Through her work, she became very critical of the position of women in society. She realized women were not seen as complete people and had little control over their lives. In her artwork, she criticizes the faults of beauty culture, comparing reality with the depictions of the "new woman" presented by the women's magazines of her time. Her collages commonly combine male and female of different races into one being. In her collages, she is very satiric and makes strong statements on gender and racial discrimination.

In her long life, she witnessed the rise of the European avant-gardes; developments in photography, cinema, and the mass media; and the disastrous consequences of two world wars on political, social, and cultural life in Europe. She met and worked with poets and painters in Berlin and Paris, and she became friends with Kurt Schwitters, Jean Arp, Sophie Taeuber, Piet Mondrian, and many others.

Hannah Höch was the only woman artist who joined the dada[25] movement in Berlin. Artist Raoul Hausmann introduced her to the dada group in Berlin in 1919. Although dadaists were in theory in favor of women's emancipation, they were reluctant to accept a woman in their group. Hannah had to fight her way in and refused to make coffees and sandwiches for her colleagues just because she was a woman.

Höch is best known for her photomontages. These collages, which borrowed images from popular magazines and utilized the dismemberment and reassembly of images, fit well with the dada aesthetic, though other dadaists were hesitant to accept her work due to inherent sexism in the movement. Like other dada artists, Höch's work came under close scrutiny by the Nazis because it was considered degenerate. The Nazis put her 1932 intended exhibition at the Bauhaus (a German art school) to a stop. They were offended not only by her aesthetic but also by her political messages and the fact that she was a woman.

Hannah Höch's collages are simple and fresh, and it is time well spent to browse the Internet and admire her work. Her art is an expression of her strong belief that society needed a "New Woman," a woman who has the right to vote, to have a professional life, to enter politics, to enjoy sexual liberty, and to play sports. Women obtained the right to vote in Germany in 1918. Hannah was concerned with the suppression and suffering of women and sought to criticize the role and position of women in society in her work. In her collages, she combines faces and body parts of men and women from different contexts, races, and ethnicities.

Conclusion

In this session, you were introduced to the essence of the workshop and you learned how to connect your narrative, your story, to your personal images and make art that is meaningful for you. We looked at a method to enter your imagination in order to find the images you want to use in your work, namely by activating your inner world: searching for images (or letting them pop up) behind the words you use to tell your story or talk about what is important for you. You practiced the method of finding images in your imagination by typing in a word in your personal Google bar and waiting for the images that pop up from out of your Inner-Net. You probably found an issue of personal interest to focus on and made a first attempt in collage (or poetry, painting, or writing, if you prefer these) to make this visible in art. You read about Hannah Höch, one of the first photomontage artists, and maybe you Googled her on the Internet to look at her artwork. You saw Hannah's very personal way of working out the issues she felt passionate about in her collages and photomontages.

Homework

If you haven't done any research on Hannah Höch, that is your homework for next week! Look at her photomontages on the Internet. If you have time, search for artists who have tackled similar issues as your own. Also, try to work for about twenty minutes a day on your first artwork if you couldn't finish it today.

Session 2
Metaphors and the Meaning of Images

What is a metaphor? What does the word actually mean? According to the *Cambridge Dictionary*, it is an expression often found in literature that describes a person or object by referring to something that is considered to have similar characteristics to that person or object: "the mind is an ocean" and "the city is a jungle" are both metaphors.

In this session, you will search to find your own personal metaphors and symbolic images in relation to the issue you are working on, and you'll explore these images in a new collage, in which you are free to use photographs of magazines, your own photographs, images found on the Internet, colored paper, paint, and other materials if you wish. Searching for metaphors will help you find personal images that symbolize the issue that concerns you.

The key to developing artistic voice is imaginative thinking—the ability to generate images, to "transfer" feelings into images, and to find metaphorical images (symbolic images) of how we feel about our personal issue. What images do you see when you hear the word *power* or *freedom*? Which animal could symbolize these abstract words? Which flower? Playing these games opens up your personal symbolic world.

The soul of art is its metaphoric, symbolic dimension. This was very strong in medieval art: the dove symbolized the Holy Spirit, the lamb was Christ, and light was a metaphor for truth. It is important to experience this yourself in order to learn to read symbols and metaphors in the works of other (contemporary) artists. Then you will be able to understand conceptual art, and you will learn to see the idea or feeling a contemporary artist wants to express. Images function like symbols to visually communicate meaning. Analyzing how multiple metaphors relate to each other brings about many details about how a certain word or idea is deeply experienced by the person who uses it. That's why it is important to ask yourself many questions and see the full image with all its details.

As you experienced in the previous session, the images that popped up out of your personal Google Inner-Net search are your personal images—metaphors in relation to the word or issue you researched. You can use these images in your personal artistic language, and you can also continue asking questions, visualizing and imagining what, where, how, and why. This is a process without end, and you simply have to dare to do it, see where it takes you, and stop when you feel you have reached a point where you are satisfied and it all makes sense. For instance, if your issue is "the position of women," ask yourself, "If I say *women*, which images do I see? What kind of women? Where are they? What is their position like? What is their main problem?" Let the metaphorical images come forth.

The theme artists work on defines not only its metaphors and symbols but also the materials they choose. The organization of the composition may also be metaphoric. The environment of the metaphoric image adds to its meaning. A painting of a rabbit in the woods is different from a painting of a rabbit sitting in the middle of Fifth Avenue. A painted rabbit is different from a rabbit made of polyester foam. It all has to do with the message the artist wants to convey. What could be the meaning of a polyester rabbit? Making art is about making conscious choices so that what we create fits with what we wanted to create. In making these choices, our feelings will play an important role. It has to feel right. Asking yourself questions and using the imagination to visualize is the key that starts the artistic process.

Today, we will search to find our own metaphors.

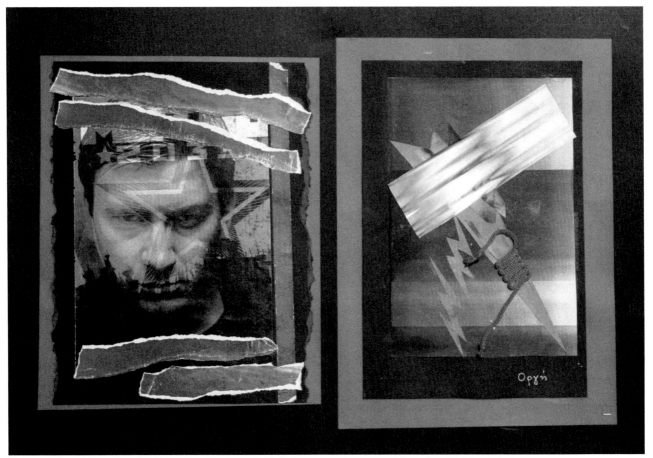

Markella, *Metaphors for Anger*, mixed media

Exercise 1

Let's go back to the words you wrote down in the previous session that were related to a specific personal issue. Ask yourself why they are meaningful to you. Ask yourself lots of questions. What images or metaphors can you find behind those words? Try out the world of objects, the four elements, the seasons, the weather, myths and fairytales, the natural world, animals, or plants. What season is *freedom*? What myth do you recall thinking about that word? Which animal embodies freedom for you? What plant could be a metaphor for fear? For joy? Which animal?

When we search for images while thinking of the words, we will find what connects us personally with them ("It is like …"). This revelation gives us many ideas and inspiration. It is called imaginative thinking, or thinking in images. Working in this way makes your art meaningful for you. It is sometimes very hard to generate images having to do with a personal issue, especially when it is an abstract concept. But images are related to feelings, so that is the road to go. Write down your personal issue or one of the words you have written down in the previous session. (You may do this exercise for all the words, if you want.) Draw a cloud around it. Think about how the word makes you feel. For instance, if it makes you feel very happy, then happy images appear. Or type it in the Google bar of your Inner-Net, click on "Images," and see the images that pop up out of your imagination.

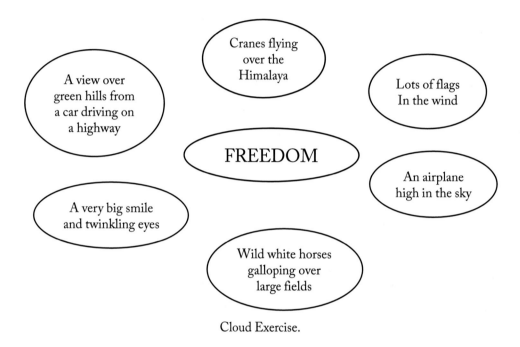

Cloud Exercise.

Exercise 2

Surrealist French poet Jacques Prévert wrote in one of his poems, "Despair was sitting on a bench." Think and write about who "Despair" was—what kind of person you imagine, what he or she looked like. If you like, use your artist's journal to write about this person.

Please read the following excerpt of a poem.

> Monogram
> by Odysseas Elytis[26]
>
> We, always, the light and the shadow
> You, always, the little star and I, always, the dark vessel
> Always you the harbor and always I the light shining from the right
> […]
> Always you the stone statue and always I the shadow that grows

You the hanging shutter and I the wind that blows it open
Because I love you and I love you
Always you the coin
and I the worship that gives it value.

If you like, read the whole poem. What images do you see behind the words of this poem? What do you think about the metaphors the poet used? Which metaphors do you connect to love? Answer these questions in your artist's journal. Now try to find metaphors in relation to your personal issue. Remember: images are related to feelings. If you use little image-clouds around the word that covers your central idea, it might be easier to find metaphors. The key to developing artistic voice is imaginative thinking and the ability to generate images, to translate feelings and memories into images and into metaphors.

Assignment

Make a collage (or work in mixed media, watercolor, painting, or other) using the images and metaphors you found. In the background, you can put images or colors that are related to what you feel or what you think about this topic (the context).

Annette's Journal

I had found a poem by the Greek poet Odysseas Elytis,[27] who was awarded the Nobel Prize in Literature in 1979. It contained examples of metaphors in poetry, and after reading them, I asked my students to really see the images provoked by the beautiful arrangement of the words in the poem. Then I asked them to think of metaphors in relation to the issue they have chosen, and to make a collage using those metaphors. I asked whether they had done their homework. Some hadn't, some had been writing, and some had made a collage. Some things looked like inquiries. I talked to them again about the exhibition, but they are quite hesitant about it. All students tried to use metaphors, but apparently it is very hard for them to generate images that have to do with their issues.

Markella had gone on a quest to find the right image/metaphor that expressed "Anger" for her. She had done a lot of work at home. She found the angry horses from the *Guernica* painting by Picasso to express anger evoked by violence. She had also done studies of wounded bulls at bull fights as her metaphors for "Anger." Anna discovered her issue, "Shadow," was by itself the metaphor she used for the way she felt the paternalistic society was treating her. When I said, "What is under the shadow?" she found a picture of a bold man covered in tattoos, seen from the back, standing in front of the darkness of the night, and surrounded by wire netting that had been cut open.

Anna, *What is Under the Shadow?*, photomontage

Tina said, "Woman is like the sea," and made a collage of an older woman with one shoulder raised and wearing glasses, in which Tina had pasted images of the sea. In the background on the one side, there were waves of a stormy sea, and on the other side was an image of a calm sea. An image of Cupid holding a bomb was flying in the air on the left.

Artist Related to This Session: Bärbel Hische (1954–)

Bärbel Hische[28] is a German artist who studied at the School of Fine Arts in Bremen. After getting her diploma, she traveled a lot and went on long trips to China and Madagascar. At present, she lives and works in Berlin. She is a multimedia artist and works in 2-D like photography, drawing, and video, but she also works in 3-D creating installations. She is inspired by the concept of time and space and by the mystery of the human psyche: the landscape on the inside. In her work, she visualizes this space within: the world of memories and feelings. For her, the space where her exhibition takes place is also a "place within," and this inspires her work so that the visitor can identify with being inside and at the same time experience the outside, sometimes as a "lost paradise" and sometimes as a reflection of the inside, the space of our desires.

Bärbel Hische works with elaborate metaphors. She uses the idea of space in various levels in her art. Her work has titles like "The Space Within," "The Space of Thought," "In Between the Spaces," "Signs," "Traces," "Desire," "Waiting Time," "Blooming Time," "The Garden of Memory," "The Oldest Fears," and "The Light and the Heavy." In her early work, she traveled through the inspiring world of the images made

in the history of art. She wanted to extract the driving force she discovered in those masterpieces. She took images of women from the Renaissance and "staged" them again, giving them a new meaning. "Looking, wondering and looking again, that is how we experience a glimpse from the essence of people that often seem unusually worldly." She created new meaning with old images because she changed the context.

In the middle of the 1990s, Bärbel Hische started producing interior installations with the intention of exploring, changing, and restructuring space with artistic means. Dealing with the aspect of three-dimensionality gave the artist more space to make statements on questions of time, on current issues, and also on her own themes with other materials and with new possibilities, involving people on the spot. She also explored land-art installations. About her video of a grazing deer called *Mistrust of the Idyll,* which one cannot go close to because of lots of filled-up plastic bags she has put in front of it, she said, "The object of our desire is far away. It looks at us we can look at it. It is in a beautiful environment. We cannot go near, yet we long for it."

Conclusion

In this session, you learned what a metaphor is and how you can find your own personal metaphors by visualizing symbolic images having to do with the issue you are working on and making associations in your mind. In the exercises, you looked at the images that popped up from your Inner-Net search, and you researched all kind of metaphors. If your issue was "Anger," what object could symbolize anger? What element, which season, what kind of weather, what kind of fairytale, what kind of animal or plant? In your quest of metaphors, it is always useful to continue with Socratic questioning: "Why is the object symbolizing anger for me an axe? Where is it, what is it like, who uses it, and what happens?" This gives you more information about the appropriate image for your artwork. If you were concerned about refugees, for instance, you could use this exercise as well and browse your imagination to find the metaphors that you think are appropriate. You learned that metaphorical images are related to feelings, so if you simply focus on the feeling you have about a certain issue, the images appear more easily. You saw how visual poems really are and learned that poems show you how to establish the link between words (the written) and images (the visual). You witnessed part of the working process of Markella, which helped you realize art making needs work and research! You also looked at the work of German artist Bärbel Hische, learning that metaphors are the essence of her work. She used a video of a deer in the woods as a metaphor of "the object of our desire we cannot go near."

Homework

Work on your assignment if you couldn't finish it. Ask yourself questions, visualize your answers, and create a collaged composition. For instance, if your issue is "the empty nest," what images and metaphors can you find? What does it feel like? What does it make you think of? ("It is like …") If you like the idea of metaphors, research the work of Bärbel Hische, or go on a quest for other artists who love using metaphors and look at their work.

Session 3
Memories

Our memory is a rich source of images. When you zoom in on a scene from the past and remember details, you can see many images and become inspired. Memories are like a treasury for the artist. Memories are part of our inner world, they are our personal history, and they are part of the collective history of the country and culture to which we belong. There are personal memories (e.g., of being a child, an adolescent, of being at work, of being unemployed, of being married, of being a new mother) and collective memories (that belong to a country, to a culture, to a continent, or even to humankind). For some people, their memories are the basis of writing their memoirs—the stories of their lives, as remembered by them.

When an artist asks, "What do I have to say as an artist?" her memories can supply rich visual material so that she can rephrase her question to, "What is my story? What do I remember?" Memory is an important source from which artists mine ideas. Especially for writers, memory is the basic tool of their art. But many visual artists have been inspired by memories as well. Korean artist Do-ho Suh's work explores the notions of home, cultural displacement, one's perception of space, and how one builds a memory of it. Kara Walker is more interested in the cultural memory of her people and is inspired by the history of slaves in America, through the memories of her grandmothers and the illustrations of nineteenth-century slavery literature. Most of the works of Mike Kelley are inspired by suppressed childhood traumas. One of the metaphors he used in his work is a blanket. A blanket represents a sense of security, and in his art he is talking about the lack of security. What would a blanket represent for you? What memories do you have of a blanket?

Many writers have published novels, inspired by their memories. One of the most famous books is certainly *In Search of Lost Time,*[29] also translated as *Remembrance of Things Past*, a novel in seven parts by Marcel Proust and published in French as *À la Recherche du Temps Perdu* from 1913 to 1927. The novel is the story of Proust's own life, told as an allegorical search for truth. It is the major work of French fiction of the early twentieth century. Here is a short excerpt to remind you of the strong visual power of a written text.

> My sole consolation when I went upstairs for the night was that Mamma would come in and kiss me after I was in bed. But this good night lasted for so short a time, she went down again so soon, that the moment in which I heard her climb the stairs, and then caught the sound of her garden dress of blue muslin, from which hung little tassels of plaited straw, rustling along the double-doored corridor,

was for me a moment of the utmost pain; for it heralded the moment which was to follow it, when she would have left me and gone downstairs again. (p. 33)

Anna, *Memories*, photo-shopped photomontage.

Exercise 1

Think of a parent, a sibling, or someone you've known all your life. Close your eyes and concentrate on remembering a specific event, or a place where you were with this person. What memories appear in front of your inner eye? Focus on remembering details of where you were. What was the day like? The light? Was it summer or winter? What was the room or the space around you like? What did the person do or say? Do you remember any smells? Did you feel any emotions? What caught your attention? Through asking yourself questions, through self-reflective thinking, you activate your inner world. You strengthen the connection between your mind (thinking) and your imagination ("seeing" images). Through asking questions, we go on a quest for details, and details are the most important aspect of art making. They show you the path on your quest to establish your own personal, artistic voice. They help you steer away from clichés, go deeper in what is your own way of art making, and find that unique mode of expression that can only be yours. Write down your memory in your artist's journal, together with all the details of the images you found through your self-reflective thinking process. If you want, make a collage about this memory.

Exercise 2

Our first memories have a strong relationship with our senses. Go back to your first memories to confirm this. Feelings, sensations, and colors unlock memories. What memory comes into your mind when you think of the color blue? Green? Purple? What memory do you have when you think of feeling calm? Happy? Melancholic? What memory comes to your mind when you taste fish or whipped cream? When you smell parsley, coffee, or roses? When you pet your dog or wash your car? There is a direct link from the senses to your memory! Write down these memories that you remember through activating your senses. Look again at the memory: Where are you? What is going on? What does it look like?

Assignment

Now go back to the personal issue you are working on from the beginning of this workshop. Browse your Inner-Net by typing "memories of (your issue)" in your personal Google bar. What do you remember in relation to that issue? What do you know of its past? What is its relation to your past? Focus on the images you see in your imagination. Focus on details, colors, and emotions. Maybe you'll even find some useful metaphors. Write down your findings and ideas in your artist's journal. How can these images inspire you to make a new artwork in collage, mixed media, or painting? Markella (working on the issue of "Anger") remembered being enraged as feeling confined and closed in, or being tied with rope. What detail from a memory you have concerning your issue can you use for a collage, photomontage, or mixed-media artwork?

Annette's Journal

I talked to them about the images of memory, and I read texts for them of people who remembered scenes from their past. I told them to research the memories they have when they reflect on the theme they have chosen. Markella struggled with a red spiraling sort of image, with a woman blinded with a cloth and about to throw a knife. Eventually, she didn't like it and changed it by using string.

> I couldn't recall any memories that had to do with anger. Remember when we did the session on memories? I could not recall any. I tried. Maybe some things with my father and my mother, maybe.
> —Markella

The session on memories worked really well for Tina. It was a kind of key that unlocked her. In the interview, she mentioned the following.

How has your work developed over the last months?

Yes, I feel there is a development, and I like it, because I have a theme. I turn around it all the time, like a shark—around and around, and I find all kinds of things every time. I think about women, the position of women in society, the complexity of women. And I am intrigued by my memories. I go through a phase where I remember many things. I am very busy with the theme of women, and I think about it all the time.

How has working on an issue of personal interest changed you?

I have become more sensitive, and it has brought me closer to my memories. I started to think of my mother, my aunts. I am touched; I have so many memories, so many images, about many things. When I was young, I didn't know them very well; I didn't know that I had deep feelings for them. And now I understand. I discover the feelings I have for them, that I have rich feelings for them. Before, I wasn't conscious about those feelings because I didn't pay attention. I never showed my feelings for them. I never embraced them or kissed them as much as I liked—not my mother or my father. I thought they were empty people. Now, through all those memories I realize, "I was there, with them, I must have appreciated them. I remember it!" And this is very important for me.…

Lately, I remembered the rubber gloves of my mother when she worked in the house, and I like the idea of gloves, to use it as a symbolic object. You know, the ones you use to wash the dishes. And I dove into my memories, and I remembered my mother. I remembered how I connect her to the idea of gloves, and I think about what it symbolized for her, because I never use gloves. And I searched inside me. But it was a sweet memory, and I struggled to see it.

Artist Related to This Session: Kara Walker (1969–)

Kara Walker[30] is among the most complex and prolific American artists of her generation. She has gained national and international recognition for her cut-paper silhouettes depicting historical narratives haunted by sexuality, violence, and subjugation. Walker has also used drawing, painting, text, shadow puppetry, film, and sculpture to expose the ongoing psychological injury caused by the tragic legacy of slavery. Her work leads viewers to a critical understanding of the past while also proposing an examination of contemporary racial and gender stereotypes.[31] Her nightmarish yet fantastical images feel very cinematic. Walker takes her figures from the nineteenth-century stereotypes of slavery literature, presenting the violent and humiliating treatment of the slaves and sexist attacks on female slaves in the form of a Victorian-style visual story. Her flat caricatures are depicted nearly life-size and arranged in narrative sequences that further exaggerate the already grotesque history of slavery. Walker first came to art world attention in 1994 with her mural *Gone: An Historical Romance of a Civil War as It Occurred between the Dusky Thighs of One Young Negress and Her Heart.* This unusual cut-paper silhouette mural, presenting an old-timey South filled with sex and slavery, was an instant hit.

Walker was born in Stockton, California. She lived with her father, who worked as a painter and professor. Reflecting on her father's influence, Walker recalls: "One of my earliest memories involves sitting on my dad's lap in his studio in the garage of our house and watching him draw. I remember thinking: 'I want to do that, too,' and I pretty much decided then and there at age 2½ or 3 that I was an artist just like Dad." [32] She originally focused on fine arts before moving to avant-garde styles. Instead of creating for the sake of beauty, she wanted to make statements and tell stories. She received her BFA from the Atlanta College of Art in 1991 and her MFA from the Rhode Island School of Design in 1994. Walker found herself uncomfortable and afraid to address race within her art during her early college years. However, she found her voice on this topic while attending Rhode Island School of Design for her Master's, where she began introducing race into her art. She had a distinct worry that having race as the nucleus of her content would be received as "typical" or "obvious." She is the recipient of many awards, notably the John D. and Catherine T. MacArthur Foundation Achievement Award in 1997 and the United States Artists, Eileen Harris Norton Fellowship in 2008. In 2012, Walker became a member of the American Academy of Arts and Letters.

In works like *Darkytown Rebellion* (2000), the artist uses overhead projectors to throw colored light onto the ceiling, walls, and floor of the exhibition space; the lights cast a shadow of the viewer's body onto the walls, where it mingles with Walker's black-paper figures and landscapes. Mixing the historical realism of slavery with the fantastical space of the romance novel, Walker seduces and involves the audience in her installation.

Conclusion

In this session, you took the elevator and descended into your past: your memories. You saw there are personal memories that stretch along your whole life, and there are collective memories that belong to a large group of people. You learned how to visually explore a memory by asking questions. You experienced how vast your memory is by connecting it to your senses. You learned how writers make extensive use of their memory and looked at an example of Marcel Proust.

In this session on memories and the past, you experienced that it is very important to remember, write, and then use the written text as a kind of scenario for your artwork. It helps making the connections in your brain between thinking and visualizing in an artwork. You looked at the work of Kara Walker, who finds the inspiration for her nearly life-size, cut-paper silhouettes in the history of slavery. Her work leads viewers to a critical understanding of the past while also proposing an examination of contemporary racial and gender stereotypes. You maybe researched her work and saw how she makes extensive use of visual details to make the representation of that history as lively as possible.

Tina said about her working process, "I don't want to work hastily. I don't want to find easy images or meanings and to combine them. I want to search for them more. And when I find something, and what I find, this can bring me somewhere else, somewhere that I hadn't thought about." Go slowly, search till you find what excites you, and go on. Embrace the uncertainty of the process and stay in the groove!

Homework

For the rest of the week, take some time every day (even twenty minutes is fine) to work on your artwork using memory as a focus, in case you didn't finish it today. Otherwise, write a few lines (or sketch if you want) in your artist's journal about memories you remember having to do with your issue that you can use for future work. When you finish your artwork for this session, ask yourself, "Where did I start? What did I discover? Where did I get stuck, and how did I solve it?"

Session 4
Colors

Color is an important aspect of making art, so we will start this session with some information about color theory. Color theory analyzes the characteristic elements of colors. It talks about shade (which hue of a color), intensity or saturation (how strong is the color), lightness (light versus dark, or white versus black), and warmth (hues of red) or cold (hues of blue). Analogous colors are the colors that are side by side on a twelve-part color wheel, such as blue-purple, and yellow-orange. Complementary colors are any two colors that are directly opposite each other, such as red-green, yellow-purple, orange-blue. How a color behaves in relation to other colors is a complex area of color theory.

Color theory took a new direction at the Bauhaus school in Germany. Its founder, architect Walter Gropius, had a vision to make art accessible to the masses. Students should experiment with material and form, with great emphasis placed on intuition. This art school became famous for supporting innovation in the arts and architecture from 1919 to 1933. The color theories that were developed during that time were new methods of associating emotions with different colors, as well as a way of grouping colors of different tones, shades or hues.

Johannes Itten taught theories on color at the Bauhaus. He created a twelve-hue color wheel that forms contrasting elements to help visualize his theories of how hues and colors can come together. On Pinterest, you can find many examples of Itten's color combinations that he created to show how a color changes when it is near another color. Itten was also interested in how colors could psychologically affect a person. For teachers at the Bauhaus, color theory became more subjective and exploratory to an individual's preferences and sensations. Part of the instruction was to have students develop their own palettes of subjective colors, which comprised a large range of choices. The question of how someone sees was explored in art, architecture, and all other aspects of design.

Artists Wassily Kandinsky and Paul Klee also taught at the Bauhaus. In their courses, they concentrated on color composition; how the presence of one color influences another, and how colors communicate. Combining colors is an art in itself! If you like colors, do some research on the "symbolic meaning of the colors" or "color psychology."

Exercise 1

What is your favorite color? Have you ever thought about why you like it so much? What does it make you think of? What feelings do you combine with pink, gray, dark blue, turquoise, or beige? What image appears in your mind when you think of these colors? How does your feeling change when the pink, gray,

or dark blue changes and becomes more intense, lighter, or darker? How do you feel about black and white? What do they symbolize for you? Which feelings and which images do they represent for you?

Play with these questions in your artist's journal. Look for colors around you, or make them yourself and write about how they make you feel. For Tina, orange meant peacefulness ("it makes me think of Buddhist monks") and for Markella warm safeness ("the sunset in summer"). Color is an excellent way to connect with your feelings. Emotion is an important driving force in making art. Try it out yourself! Write in your artist's journal about the relation between colors and feelings. Try to find images as well on your Inner-Net. Ask yourself questions and focus on what is important to you. That is how you sensitize artistic thought.

Markella, *Images and Colors of Anger*, collage

Exercise 2

On the other hand, what colors do you combine with feelings? Which colors do you combine with pain, happiness, and boredom? Use your imagination. Unclear feelings, like uneasiness, might be more differentiated. For Markella uneasiness was: "Gray with just a little red, like marbled gray." Write about the color or colors related to certain feelings in your artist's journal.

Assignment

Please investigate which color (or combination of colors) might suit the issue on which you are working. What are the hues, intensities, and saturations of these colors? What do those colors feel like? Which images do you see behind that feeling that matches with that color-feeling combination? What could be the metaphorical role of contrast between dark colors and light colors in your work? What about the use of light (and which color)? If there is light, there is shadow and darkness. What do they symbolize in your work? It doesn't matter whether you have a hard time answering. Simply sit with these questions for a week. The answer will slowly start to work inside you. For today, after having investigated which colors or hues of one color suit your issue, use those colors to make a collage on your issue. Think about your theme in color language. What is the color of freedom, of loneliness, of addiction for you? How could you find related images if you combine your issue with a color, such as "white anger, green anger, yellow anger, gray anger" (Markella's theme)? What images evoke "red feelings of women," "blue feelings of women," or "green feelings of women" (Tina's theme)?

Annette's Journal

I was too late due to an incredible traffic jam because the whole country was on strike. Everybody had started to work. I saw puzzled faces, and I asked how things were going and whether there were any questions. Markella moved restless in her chair, her body in turmoil. She had worked on her theme over the week, "Anger," and felt kind of stuck. She had cut out the horses of *Guernica* by Picasso and stuck them in her research journal. She said she liked them because they were horses, and they were in great distress and angry. She didn't like the collage she'd made the last lesson because she said that all her images "were too obvious." The red color, the girl with the knives—she didn't like it anymore, and she searched the whole week for other images that would express anger but were not too obvious. Eventually, she decided to make an abstract collage on a background of dark gray, with a very pointy red triangular shape that made me think of a knife, and red rope stuck on the "knife."

> I learned to express myself without thinking, but with shapes and colors. That worked
> so well for me, that you told me shapes and colors. It played an important role for me.
> —Markella

She had also made a composition of parts of a picture of an erupting volcano because we had talked about that image the previous time. The composition was very controlled; it showed a kind of "controlled anger." She asked me if she had done the right thing. I said it was the right thing because she was searching for images that express sides of anger. She was upset with herself because she couldn't find exactly what she wanted to do.

I asked Tina how things were going. She looked tired and was silent the whole evening. She said things were fine, she knew what she was doing, and I felt like she said it because she didn't want to talk about it. She was making a layered collage with a portrait of Virginia Woolf; an old, angry woman behind her; and a baby's cot. Her issue is now "Feelings of Women." She said she didn't want to make collages about rape and suppression of women, so she changed her theme. This lesson, I talked about color and which images the thought of a certain color evokes. As an assignment for next week, I asked them to think about their theme in color language. What is the color of freedom, of decay, of addiction? How could they find images in that way if they combined their theme with a color (e.g., white anger, green anger, yellow anger, gray anger)? Markella found bright red and fuchsia to be the colors of anger. Tina decided she would explore the color red. "Red is the color of women for me, the color of blood."

For Anna, the color of "Being under the Shadow" was black. Black for her was also the color of fear.

Anna, *Black Is the Color of Fear,* photo-shopped photomontage.

Artist Related to This Session: Helen Frankenthaler (1928–2011)

Helen Frankenthaler[33] is an artist who belongs to the group of American abstract expressionist painters that established a reputation. Along with Lee Krasner, Grace Hartigan, Joan Mitchell, Shirley Jaffe, and Sonia Gechtoff, she belonged to their era's few female painters that gained critical and public acclaim. While growing up on Manhattan's Upper East Side, Frankenthaler absorbed the privileged background of a cultured and progressive Jewish intellectual family that encouraged all three daughters to prepare themselves for professional careers. After graduating in 1949 and receiving a substantial inheritance, she studied privately with Hans Hofmann in Provincetown, Massachusetts, in 1950 before returning to New York to paint full time.

Introduced early in her career to major artists such as Jackson Pollock, Franz Kline, and Robert Motherwell (whom she later married), Frankenthaler was influenced by abstract expressionist painting practices but developed her own distinct approach to the style. Color was absolutely paramount in her work. As an active painter for nearly six decades, Frankenthaler went through a variety of phases and stylistic shifts. She invented the "soak-stain" technique, in which she poured turpentine-thinned paint onto canvas, producing luminous color washes that appeared to merge with the canvas and deny any hint of three-dimensional illusionism. Her breakthrough was later called "color field" painting, marked by airy compositions that celebrated the joys of pure color and gave an entirely new look and feel to the surface of the canvas. In color field painting, the color is freed from objective context and becomes the subject in itself. Frankenthaler applied her breakthrough soak-stain technique to other painterly media, most notably watered-down acrylic, which she used in place of turpentine-thinned paint starting in the 1960s.

Later in her career, Frankenthaler turned her attention to other artistic media, particularly woodcuts, in which she achieved the quality of painting, in some cases replicating the effects of her soak-stain process. Her work has been the subject of several retrospective exhibitions, including a 1989 retrospective at the Museum of Modern Art in New York City, and has been exhibited worldwide since the 1950s. In 2001, she was awarded the National Medal of Arts. Frankenthaler did not consider herself a feminist and said, "For me, being a 'lady painter' was never an issue. I don't resent being a female painter. I don't exploit it. I paint."

Frankenthaler recognized that as an artist, she needed to continually challenge herself in order to grow. For this reason, in 1961 she began to experiment with printmaking. As a whole, Frankenthaler's style is almost impossible to broadly characterize. Initially associated with abstract expressionism because of her focus on forms latent in nature, Frankenthaler is identified with the use of fluid shapes, abstract masses, and lyrical gestures. She made use of large formats on which she painted: generally simplified abstract compositions.

A really good picture looks as if it's happened at once. It's an immediate image. For my own work, when a picture looks labored and overworked, and you can read in it—well, she did this and then she did that, and then she did that—there is something in it that has not got to do with beautiful art to me. And I usually throw these out, though I think very often it takes ten of those over-labored efforts to produce one really beautiful wrist motion that is synchronized with your head and heart, and you have it, and therefore it looks as if it were born in a minute.[34]

Conclusion

In this session, you were introduced to color theory. You learned that colors can psychologically affect a person. Every person has a unique palette of colors—colors you like, colors that make you feel good, colors that are yours. Also, you practiced finding feelings behind colors, and you searched to find colors that correspond with certain feelings. These exercises sensitized you to feeling and understanding color. Color is maybe the most important aspect of art making. After investigating which colors or hues of one color suit your issue, you made a collage or mixed media art work, using the colors you combine with your issue. You learned about Helen Frankenthaler, who made working with color her life's goal, researched her work on the Internet, and saw how she combined color and shapes to express her feelings.

Homework

Finish your artwork over the week if you couldn't finish it. You can also take some time this week to go back to researching the color-feeling relation. Try to differentiate. If fear is white, ask yourself, "What kind of fear?" Fear of an exam? Fear you won't catch the train? Fear of a barking dog walking on the street? How do the colors change when the feeling changes? How about other feelings? Love for your child? Love of life? Love for that special someone? If you liked Helen Frankenthaler's work, you might also look at other women artists of the abstract expressionist movement featured in this short video.[35] There is a wonderful book called *Women of Abstract Expressionism* by Irving Sandler.[36]

Session 5
Dreams and Nightmares

What dreams do you see? Do you remember your dreams? Is there a dream you will never forget? In this session, we will talk about dreams and nightmares, and we'll research how they can help us to find inspiration for our artwork. Dreams are full of symbols and images, strange or fantastic. There are beautiful and mysterious dreams full of enigmas. It is the space in the depth of our souls where we meet beloved people who have died, old lovers, bears, snakes, and ants. In our dreams and nightmares, we dance, fly, and travel. We go back and forth in time. When we have a fever, we may dream of the Sahara.

The dream may be a nightmare full of stress, anxiety, or fear. That's rich material for the artist, full of images, colors, and impressions. Dreams are illusions and fantasies, the world of surrealism. Surrealism was a literary and art movement founded in Paris in 1924 by the writer André Breton with his *Manifesto of Surrealism*. Breton had studied Freud's theory on the existence of the conscious and the subconscious, and he introduced it in art and literature as the way "to resolve the previously contradictory conditions of dream and reality into an absolute reality, a super-reality."[37] Surrealism attracted many members of the chaotic dada movement. Some well-known artists of the movement were Salvador Dali, Max Ernst, René Magritte, and Joan Miró. A fairly unknown woman surrealist artist was the British Eileen Agar (1899–1991). She studied art at the Slade School in London against her parent's wishes. She then went to Paris for two years, where she befriended Pablo Picasso, Henry Moore, Man Ray, Evelyn Waugh, and Ezra Pound. Believing that women are the true surrealists, Agar wrote, "The importance of the unconscious in all forms of Literature and Art establishes the dominance of a feminine type of imagination over the classical and more masculine order."[38]

Surrealist artists and writers were dedicated to expressing the imagination as revealed in dreams, free of the conscious control of reason and convention. They tried to enter their subconscious through free association. They asked themselves, "What does it make me think of? It is like …" Freud's work with free association, dream analysis, and the hidden unconscious was of the utmost importance to the surrealists in developing methods to liberate the imagination. The world of dreams is the world where everything is possible and fantasies reign.

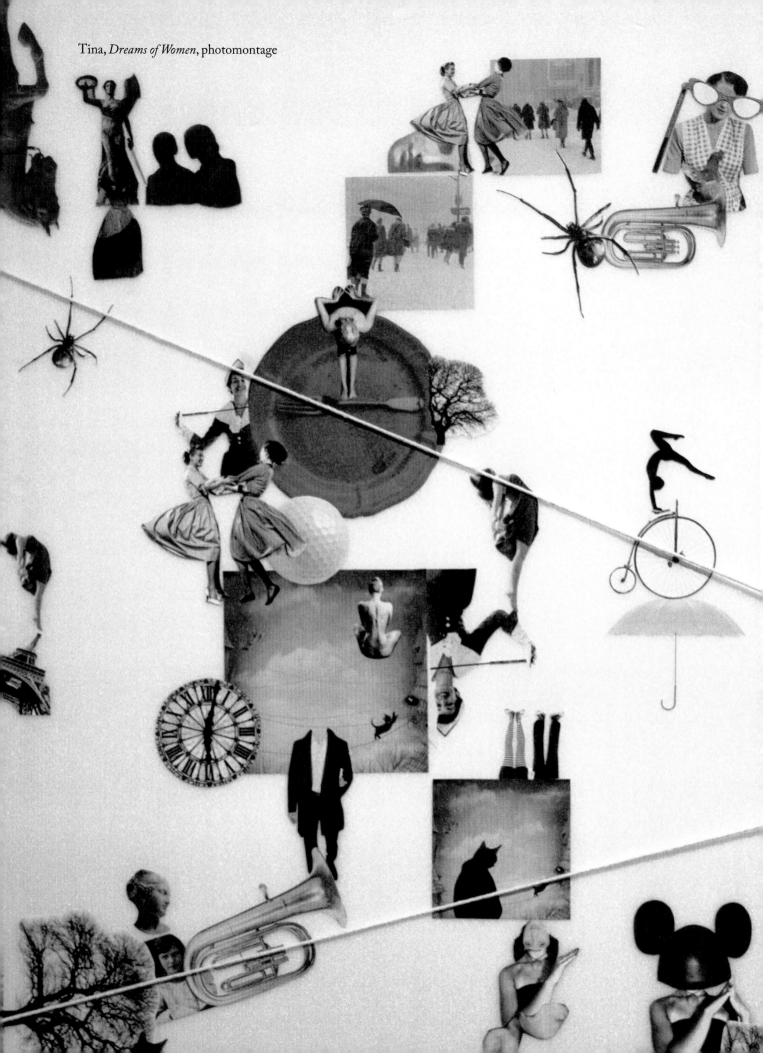

Tina, *Dreams of Women*, photomontage

Exercise 1

What images do you see behind the words *dream* or *nightmare*, and what feelings do these words provoke? Do you remember your dreams? What kind of dreams do you see? Is there is dream you will never forget? Try to remember one of your dreams, and try to remember details. Write about it in your artist's journal.

Exercise 2

We usually see dreams at night, but there are dreams that we have for our lives—big dreams for the whole world, and big dreams for us. How would you like your life to be? What dreams do you have for your life or for the whole world? Write about it, search for images your words evoke, and search for metaphors and colors. If you feel like it, make a collage about it.

Assignment

Today, you could make a collage of a dreamlike (or nightmarish) situation in relation to your personal issue, or a detail of it. You might focus on a detail of the issue that interests you. The dream could symbolize the best possible scenario of your theme, the ideal scenario. The nightmare scenario could be the worst. What really is the worst-case scenario (nightmare) of "Feelings of Women"? What would be the dream scenario for that issue? What would be the best scenario for "Anger"? Anger that finally drives a person or a nation into a transformation or a war for independence? What would be the worst-case scenario for "Anger"? How deep can we go with our creative and imaginative thinking? What colors do you see? Which images? Which metaphors?

These explorations of "thinking things through until the end" through words and images often bring us a solution, an incredible idea. Do not forget that creative thinking means to invent or discover unique connections between two thoughts or images.

Annette's Journal

Before the session started, Anna showed me three collages she'd made at home. She likes working on one central issue, and she always works with photos. When the basic photomontage is ready, she scans it and changes details using Photoshop. She doesn't like to see the edges and glue of collaged pictures. Her "Shadows" have developed into people with faces, although the faces are not real people; they are pictures of drawings, dolls, and cartoons. She told me the face of the cartoon woman in one of her artworks was very hard, just like the stone wall she was standing against. I replied, "A hard face, or a strong face?" Then she smiled.

Tina entered the gallery carrying a big bag with red cellophane and enlarged photocopies of the human heart. She loved last week's session on color and said, "This is my thing: I will make a collage with the big red heart, the cellophane, and a face of a woman." She had worked on her idea the whole week and was very enthusiastic. She got inspired by the session on color, decided to explore the color red, and found the heart and the bright red cellophane. She had said to me during last week's session, "Red is the color of women for me, the color of blood." After working on her idea for a week, today she knew what she was going to do with it. She made a remarkable collage with layers: the heart, the face of a woman in agony with a black hole instead of a mouth, and the red cellophane. Then she stitched threads all over the carton with a needle. She was very energized while working; she was in a total flow.

Tina, *Red is the Color of Women*, photomontage

The material makes it difficult because you might not find the material. That collage with the heart, I had searched for it. I wanted to combine the woman with the color red, passion, pain, the heart, the soul, the human body. I was sure about it. I found it on the Internet. I had been thinking a lot about that, and I found images on the Internet.

I wanted that shape of a heart. It was unusual, provocative, dynamic as a symbol for women.
—Tina

Markella says she's stuck in her theme, "Anger." In last week's session on color, she made a collage with shapes in red (she likes red triangles) and Picasso's *Guernica* horse. She made another collage with a bull with a mushroom-like cloud above its head from the explosion of a nuclear bomb; it was on red carton board and painted with pink fluorescent paint. It looked wildly pop art-like, and it was anger with energy and power together—a positive anger. But Markella was very self-critical about it and called it kitsch. I said, "You can also call it other names, like it's expressionist or inspired by British pop art, which sounds different." She loved that! You can call it many names, but it is good art if it feels right. I talked with her about the internal judge, that nasty voice inside that is so severe and should be given some drinks to relax a bit when we are trying out new things and enjoying ourselves. We agreed that I would remind her of him whenever I thought he was interfering in her work, and we laughed about it.

Markella was much more energetic than last week. It was interesting that she found the idea of dream inspiring to give another expression to "Anger." She said she finds it difficult, but she likes it. I told her that we want to research the process of artistic creation, so we shouldn't know exactly what we want to express; we are inquisitive.

Artist Related to This Session: Leonora Carrington (1917–2011)

I didn't have time to be anyone's muse … I was too busy rebelling against my family and learning to be an artist.[39]

Leonora Carrington was an English-born Mexican artist, surrealist painter, and novelist. She lived most of her adult life in Mexico City and was one of the last surviving participants in the surrealist movement of the 1930s. Leonora Carrington was also a founding member of the Women's Liberation Movement in Mexico during the 1970s.

In 1937, Carrington met surrealist artist Max Ernst at a party held in London. The artists bonded and returned together to Paris, where Ernst promptly separated from his wife. In 1938, upon leaving Paris, they settled in southern France. The new couple collaborated and supported each other's artistic development.

With the outbreak of World War II, Ernst, who was German, was arrested by the Gestapo because his art was considered by the Nazis to be degenerate. He managed to escape, left Carrington behind, and fled to America with the help of Peggy Guggenheim, whom he married upon arrival in New York. After Ernst's arrest, Carrington was devastated and fled to Spain. There, she suffered a psychotic break down. She describes the traumatic experience in her memoir *Down Below* (1944). In 1942, Carrington arranged passage out of Europe with a Mexican ambassador, whom she consented to marry. The pair divorced in 1943. She later married a Hungarian photographer and had two sons. She would stay in Mexico for the rest of her life.

Carrington found inspiration in the work of the fifteenth-century Dutch painter Hieronymus Bosch, which she saw for the first time in the Prado Museum in Madrid. She had an interest in animals, myth, and symbolism. This interest became stronger when she moved to Mexico and started a relationship with the émigré Spanish artist Remedio Varo. The two studied alchemy, the kabbalah, and the post-classic Mayan mystical writings Popol Vuh.

Carrington stated, "I painted for myself … I never believed anyone would exhibit or buy my work."[40] She was not interested in the writings of Sigmund Freud, as were other surrealists in the movement. She instead focused on magical realism and alchemy and used autobiographical detail and symbolism as the subjects of her paintings. Carrington was interested in presenting female sexuality as she experienced it, rather than as that of male surrealists' characterization of female sexuality. Carrington's work of the 1940s is focused on the underlying theme of women's role in the creative process.[41] The first important exhibition of her work appeared in 1947, at the Pierre Matisse Gallery in New York City. Carrington was invited to show her work in an international exhibition of surrealism, where she was the only female English professional painter. She became a celebrity almost overnight.

Her book *The Hearing Trumpet* (1974) deals with aging and the female body. It tells the tale of 92-year-old Marian Leatherby, who is given the gift of a hearing trumpet only to discover that her family has been plotting to have her committed to an institution. It follows the story of older women who seek to destroy the institutions of their imaginative society to usher in a "spirit of sisterhood." *The Hearing Trumpet* also criticizes the shaming of the nude female body, and it is believed to be one of the first books to tackle the notion of gender identity in the twentieth century.

Markella, *Dream of Anger*, collage

Conclusion

In this session, we looked at the artistic process of your three classmates. We philosophized about how dreams and nightmares can inform your artwork. You don't realize it, but your dreams (and nightmares) are a true source of images and ideas for art. Sometimes they can even provide inspiration for the composition of your artwork. The brain is in a state of heightened awareness and activity when you dream, so you see the most amazing images, colors, and compositions in your dreams. The surrealist artists used this knowledge. Just look at the work of Salvador Dali, Max Ernst, or Leonora Carrington! How can you add some surrealist flavor to your art, and maybe some humor—the humor of the impossible? You completed some exercises having to do with your personal memories of dreams and nightmares, as well as your personal images you connect to the words *dream* and *nightmare*. You worked on a collage or painting using images from your dreams or nightmares, or using your personal images that appeared behind the idea of the dream scenario or the worst-case scenario of your issue. Maybe you even liked that idea, and you did them both!

Homework

Please do some research on the Internet on surrealism and surrealist artists like Eileen Agar, Max Ernst, and Leonora Carrington. They used the idea of dreams, illusions, and fantasy in their work, and this will give you so many ideas for your own work. The surrealists liked to take completely dissimilar objects or images and put them together in the same piece of art to surprise and even shock in the same way that dreams can do. It is very liberating to look at surrealist art and try it yourself. Become a child again and play. Finish your artwork for this week!

Session 6
Feelings

Let's start this session with a question: "How do you feel right now?" It might be difficult to answer because usually you can name a series of feelings that you simultaneously sense. You might be happy you decided to do this session today and curious about what it will bring. Perhaps you are feeling interested, energetic, calm, or amused. Or maybe you are displeased, frustrated, impatient, or anxious. Feeling is the blood that animates our lives; it gives color to our experiences. Feelings give meaning and importance to our memories, our thoughts, and our dreams. They are the key elements of our character! Feelings are the most useful tools for the artist next to memory, metaphor, and color. These lead to inspiration and useful ideas!

A good exercise to sensitize your feelings (again) is to look at something like a view, a landscape, an object, or a person. Anything. Look at something small like a flower, an egg, or a biscuit. Or look at something big like the view from a mountain, a street full of cars and people, or a large animal. You might be able to look at these things in reality, or you can see them in a magazine or book. Write in your diary about how what you see makes you feel. No rational thoughts, only phrases like "I feel …" and "It makes me feel like …" You may say, "I feel beauty, softness, togetherness, harmony, and promise." Or you may reply, "I feel anxiety, suffocation, overwhelmed, out of control, afraid, and angry." This is a good exercise to sharpen your feelings.

There is a wonderful link between feelings and colors. Colors can help very much to get in touch with your feeling and sensing. You might concentrate on a particular feeling and find a matching color, or you find a color and describe the matching feeling it gives you. The feeling-color combination may help you in making your artwork. Check the lesson on color and see what you learned there. Look at the exercises of session 4. There, you started with a color; now, you should concentrate on a feeling first.

As the focus of the workshop is the generation of an issue of personal interest, feelings play a paramount role as a tool to zoom in closely onto images for all three women I monitored. They refer to "deeper feeling," a result of really trying to feel this self-chosen issue of personal interest. We spent a whole session talking about the color different feelings have and the feelings behind the colors. The women were genuinely surprised by each other's responses. ("Is yellow the color of hate for you? But yellow is such a happy color!") Colors helped to sensitize students to feelings. In the first sessions some women insisted they couldn't see any images behind words, but the fact they discovered feeling (what does it feel like) in this session opened doors. The exercise on finding colors behind feelings, and feelings behind colors, helped a lot in this (What is the color of boredom, of frustration? What feeling is lime, blue-gray, or orange?).

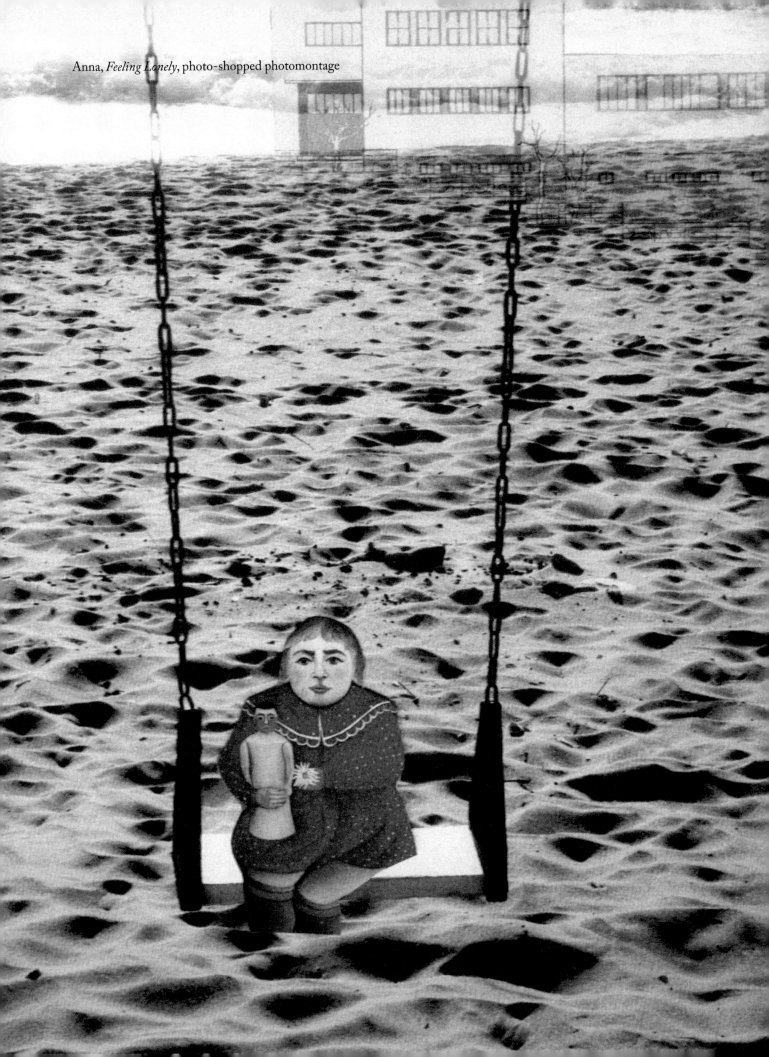

Anna, *Feeling Lonely*, photo-shopped photomontage

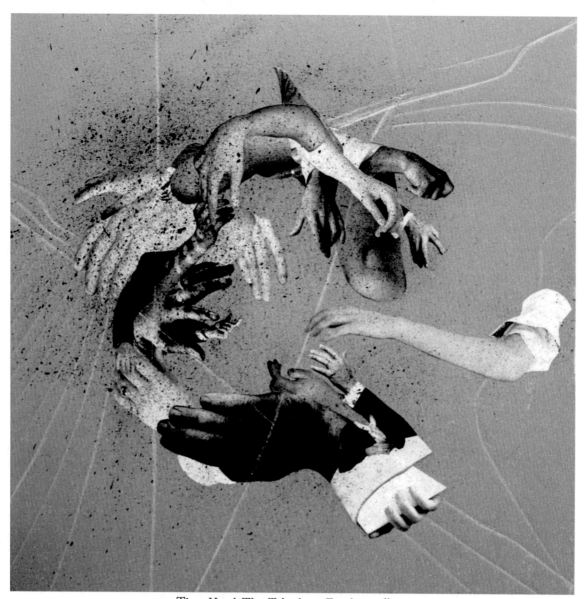

Tina, *Hands That Take Away Freedom*, collage

The sessions about feelings and memories came very close. I learned about myself, about my fear, what I am afraid of, and what my fear was about. I thought I would use black, but eventually I used a more happy color for my fear. I don't know, but eventually my fear wasn't a dark fear, a fear of maltreatment. It was more; it had to do with my freedom, that nobody holds me or restricts me. Remember the collage I made with the hands? That's what I wanted to say. I don't want you to restrict me. That gives me fear: that you take my freedom. —Tina

Exercise 1

Take your time to look at the lists of feelings in Appendix A and B at the back of this book. Try to feel each of the listed feelings. Which feelings do you recognize because you feel them regularly? Which are your favorite feelings? Which are the feelings you don't like? Write about all this in your artist's journal. If you feel like it, choose one feeling and make a collage using the images that emerge from your imagination when focusing on that feeling.

Exercise 2

Have a look again at the feelings in Appendix A and B. Choose some positive and negative feelings that resonate with you. Maybe they resonate with your chosen issue. What is the color of each feeling? Take a brush, paint and paper and paint these feelings in an abstract way. Focus on making a composition of "lines". If your feelings were "tender," "surprised," "confused" and "hesitant," try to create tender lines, surprised lines, confused lines, and hesitant lines in their appropriate color. Maybe you discover you like abstract painting!

Assignment

Which feelings do you have about your issue that you want to explore today? For inspiration, look again at the lists in Appendix A and B. Your issue might be friendship or motherhood. There might be many feelings connected to your issue. Choose one. Look for images and metaphors on your Inner-Net that match this feeling about your issue. Think what color suits your feeling. Look for pictures in magazines; find shapes and colors that match your feeling, and start making your artwork.

> I start to express this "under the shadow" feeling slowly that I have now. Like there is something on top of me that puts my head down; it imprisons me a little. Because I feel it, I work on it, and I can express it.
> —Anna

Annette's Journal

Tina was all happy and came in with a big sheet of a kind of foam, as well as a lot of small pictures of women, spiders, bicycles, cots and more she had cut out from magazines, all ready to be stuck on the big foam sheet. She had done this work at home and at her office during her breaks. It was work done for the session on dreams of the previous week. She was very enthusiastic about the idea of making a collage on feelings of women as a dream. She chose the foam board for the collage to be made on dreamlike material: foam! I sensed a lot of flow. She experienced a lot of joy in making it; she never sighed or moaned like last week.

Anna and Markella like to absorb ideas and information during the session, and then they take their time to think. They search through the magazines for images that click, but they do most of the work on the collages at home. They need to think about it, they say, and they "need their time." I showed the students images from the book *How Does It Feel?*[42] and asked about which feelings these images provoked. They liked that. I told them they should try to use the visual language, not to think too much in logical schemes, but in schemes of color, feeling, metaphor.

Markella was much more energetic than last week. I told her that we want to research the process of finding what message we want to express through art—the process of developing artistic voice—so we might not know yet exactly what we want to express, but we are inquisitive. She is clearly insecure about it all, and she wants me to tell her what she should do, but I don't. I support her a great deal when she tries something new. She has understood the concepts of process, exploration, and play, and she likes them, but there is still much resistance. If she would start to trust her own inner world more than the opinion of the outer world, she would get closer to genuine artistic expression.

> Well, as I have a strong judge inside me … That's why I doubt so much … I don't know if what I do is worth anything. I have become milder now, but still I don't know if it is worth anything. If I would see my work in an exhibition, I don't know if I would like it … If an experienced collage artist would judge them, I don't know if he would think they were worth anything. —Markella

Today, Markella had done a lot of work at home. She had made a collage showing a flame in a cage floating on the ocean and being threatened by a huge wave. She had been inspired by the idea of dream/nightmare just like Tina. She liked it that she had found her personal symbol of anger: a flame in a cage. She made a collage with the waves of the sea, a cage with a yellow-red flame, and a mermaid tied in rope. She said she thought of anger as the rage of nature. She got this idea because of my idea of juggling with themes and colors in order to activate the imagination: "What images do you see when you think red anger, green anger, yellow anger, blue anger? How does that feel?"

Markella felt "blue anger" resonated for her, and she felt that 'blue anger' was a storm at sea. She visualized this in a new collage. She had found big blue waves, and in the foreground were a lot of black rocks. We discussed that the power of the big wave and the sharp black rocks also function as a metaphor for rage, in the sense of the dangerous, violent force of nature perceived by many as the rage of nature. This could be a metaphor for the blind rage we sometimes perceive. She was very insecure about it and kept asking if it was good, if it made sense, if it was stupid, if I liked it, what she should change about it, and if the message was clear.

Markella, *Blue Anger I*, photomontage

Artist Related to This Session:
Lee Krasner (1908–1984)

Lee Krasner was an abstract expressionist painter and collage maker. Abstract expressionist artists were committed to art as authentic expressions of the self, born out of profound emotion and universal themes. Krasner was a passionate woman. She would often cut apart her older drawings and paintings to create her collage paintings. She called this "self-cannibalization". She also commonly revised or completely destroyed an entire series of works due to her critical nature.[43] As a result, her surviving body of work is relatively small.

Lee Krasner became famous because she married Jackson Pollock. A native of Brooklyn, New York, Lena Krasner was born to an immigrant Russian-Jewish couple. Her early art training was at the Cooper Union, Art Students League, and the National Academy of Design in New York, where she studied from 1928 to 1932. After graduating from the academy, Krasner took college courses toward a teaching certificate and worked as a model and waitress. In spite of the onset of the Great Depression, she did not give up hope of becoming a full-time professional artist.

In 1937 she returned to art school, this time at the Eighth Street atelier of the celebrated German émigré Hans Hofmann, who transmitted principles of modernism from Munich and Paris to New York. Most abstract expressionists were shaped by the legacy of surrealism, which they translated into a new style fitted to the postwar mood of anxiety and trauma. Political instability in Europe in the 1930s brought several leading surrealists to New York, and many of the abstract expressionists were profoundly influenced by surrealism's focus on mining the unconscious. She was associated with Hofmann's school through 1940, and during that period she radically revised her visual language. Continuing her active involvement in artistic, political, and professional causes, Krasner joined the American Abstract Artists, showed her paintings in the group's exhibitions, and rapidly gained credence as a younger-generation modernist.

Krasner met Jackson Pollock in an exhibition in 1941. She responded immediately to Pollock's work, believing that he was "a living force" with whom others would have to contend. She introduced him to numerous artists and critics who could help him further his goals. Krasner and Pollock's marriage in 1945 and their move to the rural village of the Springs, near East Hampton, Long Island, turned out to be artistically rewarding: in 1946–47 she began to produce her first mature statement, the Little Image series, dripped linear networks and rows of tiny runic forms.

During the period of 1953-55, despite marital problems centered on Pollock's alcoholism, Krasner made a significant technical move into the medium of collage. Using color field paintings from her first one-woman show (1951) which she considered unsuccessful as a support, she pasted large, dramatic shapes cut from her own and Pollock's discarded canvases in works such as *Milkweed* (1955). In her own words, she said she wanted to make abstract art with a psychological content. In these important works, her admiration for Henri Matisse is clear.

By 1956 her relationship with Pollock was in ruins: he was drinking heavily and had taken a mistress, and he was no longer painting, whereas her work was rapidly progressing. At this crisis point in her personal and professional life, Pollock was killed in an automobile accident, and Krasner was left with the emotional aftermath. The film *Pollock*, directed by Ed Harris, gives a fine impression of the role Lee Krasner played in her relationship with Jackson Pollock.

Conclusion

In this session, we looked at feelings. In the exercises, you tried to feel the feelings and imagine images appearing in front of your inner eye when concentrating on the specific feelings. You researched the link between feelings and colors again, as a follow-up of session 4, and tried to paint these feelings. Then you also focused on the feeling you have in relation to your issue, and that guided you to making a collage

or painting about this specific feeling. The artist for this session, Lee Krasner, belongs to the abstract expressionists, the group of American artists who came to prominence in the fifties and whose focus was to express feeling in an abstract way. Lee Krasner used abstract shapes and colors to make "abstract art with a psychological content," as she called it. Markella liked that technique a lot; it helped her to give shape and color to her issue, "Anger."

Homework

If you haven't finished, try to finish your collage or painting having to do with the images of a chosen personal feeling about your issue. If you like, do some research on the Internet on the abstract expressionists and the art of Lee Krasner. Don't forget that when you finish your artwork for this session, ask yourself, "Where did I start? What did I discover? Where did I get stuck, and how did I solve it?"

Session 7
Spirituality and Personal Symbols

In the beginning, when you told us about spirituality, I thought, I cannot touch on that. That is too deep. I cannot touch that. But then I felt a strong reaction. I wanted to do something about consumerism because it was Christmas, and all the shops were full with things. And I made the collage with the woman with the Christmas tree on her head and all the boxes, and it came out so naturally. I put it aside. Then I thought of the idea that everything is connected, and I made another collage and put it aside to make the collage that really expressed me, the one with the rainbow. So it is a development. It changed me because in the beginning, I was so resistant about it. And I said spirituality—I am not going to occupy myself with spirituality. I am too young for spirituality, and eventually something came out of it, and I was very happy with the end result. It changed me. The course of the collages—in the beginning I was resistant, but it changed me. It softened me. It lifted me. And I learned something about myself through the session on spirituality: to think in a different way.
—Anna

The first basic step "to finding what someone's spirituality is" could be interpreted as, "What do you believe about life, and about your life? What is meaningful for you?" There is a tremendous difference in consciousness about personal spirituality between people. The most general meaning of the spirituality of a person would mean the deepest values by which she lives. Spirituality comes from the Latin *spiritus*, which means spirit, soul, and ultimately life-giving force. Experiencing your spirituality means experiencing how your cultural background and beliefs about life and the self have crystallized within.

In order to be an artist, you need to be in touch with the cultural and natural surroundings that have shaped you as a person. You need to be conscious of this so that you can use it, access it, and connect to it as a source of inspiration. I don't want to concentrate on spirituality as "the search for the sacred," but rather on spirituality as your internal experience, the discovery of what you value, what you believe in, what you hope for. When women hear the word *spirituality*, they become nervous at first. It means touching "the great insecurity," touching "the world beyond this world." I define spirituality as "what is there right now." What do you believe right now about life, and about yourself? What inspires you right now?

Tina, *Spirituality of Women*, photomontage

The word *spirit* is the basis of both *inspiration* and *spirituality*. There is a connection between the two! Which images do you see when you say the word *spirituality*? Usually students mention religion, God, and sermons, and they immediately add they are not going to make a collage about this. Then I bring them back to themselves by saying that apparently, they experience spirituality as being outside of themselves. I remind them of the exercise in the first session, where we described the road from our house to another place, only in images, and how we all had different images and different perspectives that reflected our personal experiences.

When I asked students what kind of tree they saw, there were olive trees, pine trees, chestnuts, lemon trees, small trees, large trees, trees in spring, trees in winter, and trees by the sea. What images do you spontaneously see when you think of *spirituality*, if your intention is on the same neutral wavelength as when you found images for *tree*? Anna found "light shining on diamonds" and "light shining through a rainbow." Markella found "an eagle flying high," "Pegasus the winged horse," and "the inspiration of poets." Tina found "a spiral" and "layers."

Spirituality is a prism through which we understand, interpret, and feel art. Our spirituality is the umbrella for our minds, feelings, memories, and metaphors. It is the deeper dimension of our souls; it is the basis of who we are. Spirituality aligns the sense of self to something greater than we are, and to life in general. It is an important aspect for growth because it opens new dimensions of thinking. It makes students realize that there is a potential of growth as an artist, that they have so many possibilities to develop themselves further, to discover and learn, as long as they accept the quest to go deeper, ask themselves questions, and visualize their process. As a metaphor of how their work can evolve, I tell them that if you have an adult goldfish in a tiny aquarium, it will never grow more than two inches, whereas if you put it in a big aquarium, it will grow up to six inches. If released in a pond, it might grow up to one foot.

"Anna, *Spirituality*, photo-shopped photo"

Exercise 1

Ask yourself which images you see when you say the word *spirituality*; write in your artist's journal about these images. Don't forget to ask yourself questions. If you say "an angel" or "helping others," ask yourself, "What kind of …? What it is like? Where? What do I see? What happens?" What relation do these images have with you? Make a collage or a painting using these images.

Exercise 2

What do you value in your life? What do you believe in? If you visualize "me" or "my life," which images would you see? Write about this in your artist's journal, and if you want, make a collage, a sketch, or a painting. You might think of making a "mood board." Interior designers, architects, and photographers make mood boards to visually illustrate a specific style, feeling, or mood with which they want to work. You might make a mood board for your holidays, for a book, or for the remake of your house. Mood boards are used to inform clients of the overall feel of an idea. Think of yourself in this way. You can image yourself to be a brand. What do you want other people to know about you? What is your specific style, feeling, or mood? Pick out images that resonate with you as a person and with what you value.

Assignment

What do you believe about your personal issue? What is your opinion? What do you believe in concerning "the empty nest," "divorce," "loneliness," or "freedom"? What do you think about it? Go back to the personal issue you are working on and try to answer these questions in writing. Next, underline some of the words and search for images, colors, feelings, and metaphors you can associate with those words. When there is something that clicks and inspires you, use that image (or those images) to make a collage or painting.

Annette's Journal

Tina liked the idea of spirituality. She used the face of a woman from the Renaissance (from a painting) and stuck a mask-like part of another face (a photograph this time) over the eyes. Behind this, she stuck part of the face of another woman (a photograph) looking straight at the viewer. It was an interesting layered composition. Tina likes to use strong images of love and hate, dancing people who are light and airy, but also burning black eyes in a face covered with bright red cellophane. She loves intensity and passion, but there is also a lot of sensitivity in her work. She worked quietly this time, although she was tense because she couldn't get it right. Eventually she fixed it but said she wasn't happy with it and couldn't do it the way she wanted. I said I liked how well the colors matched and how mysterious the layering worked. She wanted to finish it at home.

Anna likes to work in a minimal way. She likes to filter things down to the very necessary. During the interview at the end of the twelve weeks, she explained this.

I developed a style that is closer to me. As I told you before we started the interview, I want to throw away too many words, too many voices, the "too much, too much, too much." And I wanted to keep that which is enough for me. That is what I also try to do in my collages. Slowly, slowly. Can I tell what I want to tell with fewer images? And with how many fewer images can I tell what I want? There in frugality, I want to work. It has to do with my own life. I had too many stimuli and too many things, and I gathered and consumed, and in a certain moment I wanted to get closer to nature—more harmony, less weight to carry. And that shows in my collages. But I owe that to you, to the road you showed us, that inspiration should come out of us. And you said find an issue of personal interest you feel passionate about. —Anna

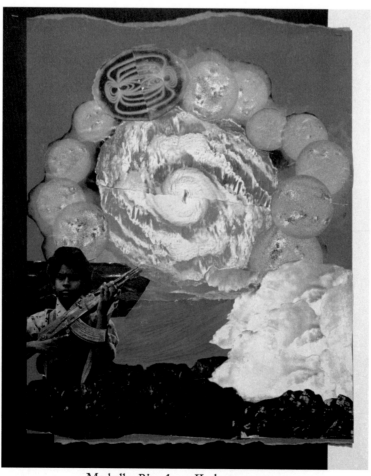

Markella, *Blue Anger II*, photomontage

Markella was very confident this time. She said anger has a side of suppression, of being held back (the ropes, the cage). She got rid of the feeling that she had to work in red because red is the color of anger. She had done research and found a picture of El Niño, and a kid soldier holding a large rifle. She liked the fact that the collage was blue overall but still expressed anger. It was much larger than her usual work. She felt her theme was developing, and she was content. She had felt blocked for the first five sessions. Last week, I gave her the book *Women Artists*,[44] which is on feminist art, and I told her that rage and anger are a typical characteristics of feminist art because women are being suppressed in the paternalistic society. She said that she didn't like the book in the beginning, but that she looked at it again and again, and then she understood it and liked it.

Artist Related to This Session:
Sophia Kyriakou (1974–)

Sophia Kyriakou[45] was born on the Greek island Syros and lives and works in Athens, Greece. She obtained her MFA at the School of Fine Arts in Athens, where she studied painting under the Greek artist Yannis Psychopedis. She has taught painting at the Department of Applied and Visual Arts of the University of West-Macedonia in Florina, Greece (2007–2011). She was the co-owner of Owl Art Space, a private art space at the foot of the Acropolis, from 2012–2014. It was called Owl because that is the bird of the goddess Athena in Greek mythology, and it is the symbol of wisdom. The idea behind Owl Art Space was to create a space where art and science could meet. Sophia wanted to change the paradigm that an artist exhibits in a gallery. She wanted to create a neutral space like a project room where artists could exhibit their work, and they would meet in the evening with scientists and the general public for lectures and roundtable discussions. She thinks that in the arts, you have to be true in what you say and do. You have to be able to explain your art and open up that narrative for others to participate in it.

In Kyriakou's mixed-media artwork, spirituality and mysticism play an important role. Ever since she was a child, she was in touch with her inner world. She vividly remembered her dreams, images from landscapes she had visited, and meetings with people. As a child, she discovered she could continue her dream where she'd left off the night before. This inner world was as important as the outer world. When she became an artist, she realized that in her work, she lived in a dream but in the outside world too, at the same time. Through art, she had easy access to that state. In her mixed-media work, she visualizes parallel thoughts or fleeting glimpses at things and events, such as when the day ends and we remember everything like a dream. The white color she uses is dominant in order to impart the dreamlike nature of events.

She started her career using collage art but then turned to materials that had a more "alchemical," spiritual dimension like salt, water, wax, and charcoal, and she began to work in 3-D. According to Kyriakou, water is an incredible substance; it is like a microchip, and it has memory—the memory from the creation of the earth, of humanity. In one of her projects she created islands by pouring hot wax into water. In order to

do research for this project, she read "The Tale of the Unknown Island," José Saramago's short story from 1997. It is about a man who wants to find the Unknown Island. Everybody says he is crazy, but he leaves anyway with a boat he has called *Unknown Island*. The story ends magically with the following sentence: "And thus the *Unknown Island* set sail in order to discover herself." When Sophia read this sentence, it determined her process. She realized she made art in order to discover herself, to set sail and discover that magical side embedded in her spiritual view of her life. It was this magic that was at the basis of Ulysses' ten-year-long attempt to go home to the island of Ithaka, of which he was the king. After reading Saramago's story, working on her wax islands project, and thinking about how much she loved Ulysses' journey as a metaphor of a life journey, she suddenly realized that she too was born on an island, the island of Syros, and it all made sense to her.

In working with salt, water, wax, glass, and charcoal, her artistic process has become more tactile. These materials intrigue her because through them she can express her inner spiritual world in the real world. She thinks art making is like an interesting journey that starts from her spiritual imaginary inner world and ends with an artwork in the real world.

Conclusion

In this session, we looked at another part of you. Next to your personal metaphors, memories, colors, dreams, and feelings, we looked at what you value, what you believe. Pondering on what you believe about certain things is a very useful focus to find inspiration. It opens many doors in your mind and imagination. You might find new ways of looking at certain issues, and consequently you may find new images. You visualized which images you see behind the words *spirituality* and *me*. Maybe you collaged a mood board about yourself, your style, your essence. You also looked at what you believe about your personal issue and created a collage or painting of this. We looked at Greek artist Sophia Kyriakou, who pierces deep into the meaning of symbols, materials, and metaphors in her work.

Homework

This was a dense session with a lot to think about. Write about your spirituality in your artist's journal; research images and visual material if you like. Look at the work of Sophia Kyriakou online. If you couldn't finish the exercises or the assignment, try to work on them during the week; twenty to thirty minutes a day is sufficient. Don't forget when you finish your artwork for this session, ask yourself, "Where did I start? What did I discover? Where did I get stuck, and how did I solve it?"

Session 8
Meaning and Materials

This session will inspire you about how you can use various materials for your artwork and how you can make your own materials. The idea for this session is to connect meaning with material in order to give shape to your thoughts, feelings, dreams, or memories about the issue on which you are working. In the narrative about your issue, you will find clues, words, images, and meaning that will help you find connections with materials and ideas for compositions. Remember Tina, who used foam board for her collage "Dreams of Women"? She connected the lightness and airiness of the foam board to the volatility of dreams. In this session you will also try out three-dimensional art. Everything that is lifted off the paper, out of the surface, or put up straight is three-dimensional art! The possibilities are endless because there is a vast array of materials available to you.

Connecting meaning with materials and composition will give you the space to think about which materials suit your issue. There are lots of options: you may think of found paper, cardboard, cardboard boxes, clay, plastic foil, cellophane, foam boards, isolation foam, plastic bags, cello tape, plaster tape, papier-mâché, or even chicken wire! Artist Sophia Kyriakou started her career using collage art but then turned to materials that had a more "alchemical," spiritual dimension like salt, water, wax, and charcoal, and she began to work in 3-D. According to Kyriakou, water has memory—the memory from the creation of the earth. In one of her projects she created islands by pouring hot wax into water. Artist Faith Ringgold made painted story quilts—art that combines painting, quilted fabric, and storytelling. These very original "story quilts" elevate the sewn arts to the status of fine art.

What can you think of that would match your idea? Research using unusual materials: explore the characteristics of these materials and check if these suit the issue on which you are working. Is the material flexible, soft, light, heavy, cold or hard? How do these materials relate to your memories, to yourself? What feel does your issue have? As you will see in this chapter's "Annette's Journal," Tina used a kitchen glove for her artwork, as a symbol for the memory of her mother. No need to go far! What materials could you use for motherhood, friendship, grief, or blooming? Use your imagination. If you want to find what materials you could use for the issue of friendship, break this large concept down to details using Socratic questioning. "What does friendship make me think of? What image do I see when I say *friendship*? What is the most important aspect of friendship for me? What image do I see behind that word?" You could ask yourself these questions for any issue. Questions zoom in on what is particularly important to you.

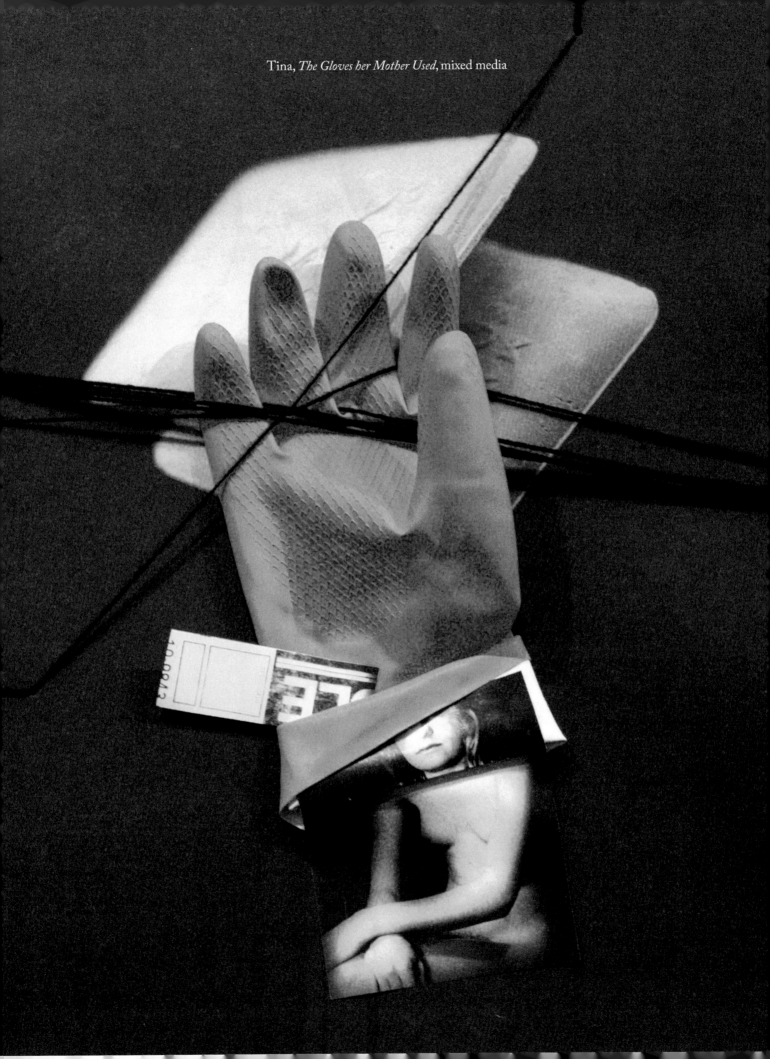

Tina, *The Gloves her Mother Used,* mixed media

In addition to photographs, and all kinds of found materials, you can produce your own materials for collages, or three-dimensional artwork. It would be fun to browse various YouTube instruction videos about making your own paper using a cheap plain mixer, a sieve, and a variety of different kinds of papers: newspaper, wrapping paper, and white or colored cardboard. You can add leaves, seeds, aluminum foil, and anything else you can think of. It is easy to make your own paper combinations, and it is a lot of fun to experiment with something new. You simply put all your found paper in the mixer with enough water to make your paper porridge. Then you empty the contents of the mixer on the sieve, press it with a sponge, let it dry for two days, and that's it! There are also plenty of YouTube instruction videos available about how to make papier-mâché, or papier-mâché clay if you feel you'd really like to build your own shape.

Exercise 1

Explore making a collage in three dimensions. The easiest way is to fold a piece of cardboard in two or three and lift it up from the table. It is intriguing to discover the sudden possibilities of "the front" and "the back," cutting holes, making windows and doors, making balconies, and sticking other paper constructions or photos behind these openings. You might also want to explore adding materials like plastic, cloth, and all kinds of small objects, like paperclips or pins, for an original composition.

Exercise 2

Find any empty box that is to your liking: a shoebox, a cardboard box for paper, or a box for oranges. Choose a size you like, a size that appeals to you. If this box was a self-portrait, what would it be like? If it was the "Box of My Life," or the "Box of My Dreams," what would it be like? Choose one of the options. If you want, you can paint the sides first and then add collage or three-dimensional objects. There is an inside and an outside; which feelings and images do these words evoke in you? Explore cutting out parts of the sides or the corners if that feels right.

Assignment

After doing the exercises, start to design your 3-D artwork based on your personal issue for which you may use any materials to your liking. If you liked working with a cardboard box that is fine! Create the "Box of –your issue–." Explore the meaning of materials that would fit this personal issue; maybe dyed paper, pages with printed texts (poems or parts from your diary), or self-made paper. Investigate how you could use other materials (foam, string, plastic, wood, metal) or objects with a symbolic meaning for you (safety pins, paperclips, beads, household gloves, etc.). Start thinking about your idea, develop your concept, and visualize it in your imagination. Write about your findings in your artist's journal. Now you can start making your project!

Annette's Journal

"I don't want to work hastily, I don't want to find easy images or meanings and combine them; I want to search for them more. And when I find something, and what I find, this can bring me somewhere else, somewhere that I hadn't thought about. And then I say, Look what I found!"
—Tina

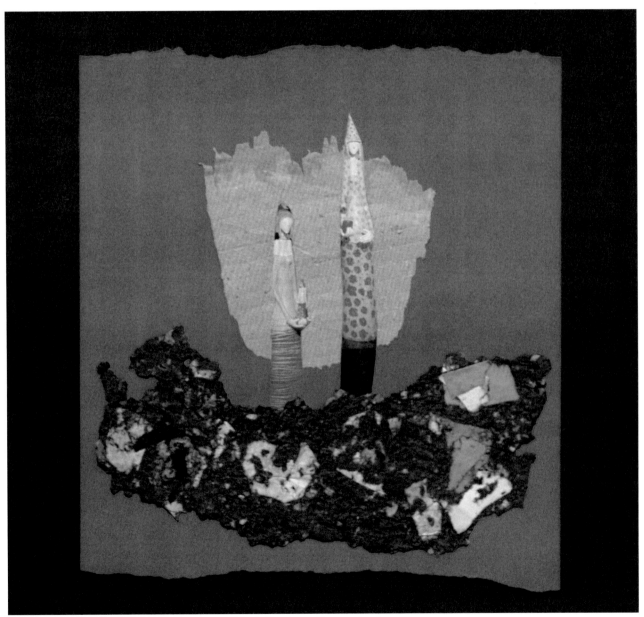

Markella, *Angry Paper*, mixed media

In this session I told the students to try to get out of their comfort zone, and try new materials and ways of art making in order to make new discoveries. They remembered the goldfish I had mentioned in the previous session, and agreed that it would be great to swim in a pond this time. I had brought a mixer, sieves, and sponge cloths, and I showed the paper-making technique. Some students gathered around the mixer, and others tried out the three dimensional collage. They were intrigued by the sudden possibilities of "the front" and "the back," cutting holes, making windows and doors, and making balconies. Markella made an interesting 3-D collage. It was a bright red building with windows and a black knife sticking out of one of the windows. Next to the building, she had glued lots of knifelike red carton shapes. Knives are her personal metaphor for anger. When I asked her if I could make a picture, she refused. She told me much later that she had thrown away this artwork.

Markella wanted to make a passe-partout with self-made paper for one of her collages, and she asked me about how she should do it and how she should stick it. She made "angry" black paper by throwing a lot of black cardboard, red paper and pictures into the mixer, and letting it spin just a little, so that the paper turned out very rough with big, torn-up pieces. Eventually, she had not made enough black self-made paper to make a passe-partout, and she dropped the idea. She used some of it in a collage with two figures standing on top of it. After the papermaking Tina went back to her chair to stitch very thin paper with needle and thread into tiny collages. The thin paper made her think of the sensitivity of women. She said stitching is a women's practice, and she was thinking of also including some knitting around one of her collages. Anna loved the paper making technique. She discovered she could put pieces of photographs on the sieve, before adding the paper pulp from the mixer. After pressing the pulp on the sieve, and turning the wet paper upside down, the added pieces had stuck onto the pulp, creating a fun composition.

After the session, we sat down and talked about the upcoming exhibition. There was hesitation and insecurity. The students said, "Should we show everything?" I said yes, because it shows the process. They weren't too sure about showing the "bad" artwork, so we'll see what happens.

Artist Related to This Session: Faith Ringgold (1930–)

Internationally celebrated multi-media artist, teacher, art professor and author Faith Ringgold is best known for her painted story quilts—art that combines painting, quilted fabric, and storytelling. Her famous quilt, *Tar Beach*, resides at the Solomon R. Guggenheim Museum in New York. Ringgold combines her African heritage and artistic traditions with her artistic training to create paintings, multimedia soft sculptures, and "story quilts" that elevate the sewn arts to the status of fine art. In 1983 she began writing stories on her quilts so that when her quilts were hung up to look at, people could read them. The fact that Ringgold's great-great-great-grandmother was a Southern slave who made quilts for plantation owners suggests a further, perhaps deeper, connection between her art and her family history.

αφέλεια
ελαφρότητα
ελευθερία

Tina, *Feelings of Women,* rice paper

Faith Ringgold was born the youngest of three children. Her parents descended from working-class families displaced by the Great Migration. Her mother was a fashion designer and her father an avid storyteller, so Ringgold was raised in an environment that encouraged her creativity. After the Harlem Renaissance, Ringgold's childhood home in Harlem was left with a vibrant and thriving arts scene. Because of her chronic asthma, Ringgold explored visual art as a major pastime through the support of her mother, often experimenting with crayons as a young girl. In a statement she later made about her youth, she said, "I grew up in Harlem during the Great Depression. This did not mean I was poor and oppressed. We were protected from oppression and surrounded by a loving family."[46] With all of these influences combined, Ringgold's future artwork was greatly affected by the people, poetry, and music she experienced in her childhood, as well as the racism, sexism, and segregation she dealt with in her everyday life. In 1950 Ringgold enrolled at the City College of New York to study fine arts, but she was rejected by the male-only program and instead studied art education.

Ringgold's artistic practice was extremely broad and diverse and included media from painting to quilts, from sculptures and performance art to children's books. She also made fabric "dolls" and larger stuffed figures, many of which resembled real individuals. As an educator, she taught in the New York City public school system and at the college level. In 1973, she quit teaching public school to devote herself to creating art full time. She traveled to West Africa in 1976 and 1977. These two trips would later have a profound influence on her mask making, doll painting, performance art and sculptures.

Ringgold's early art and activism are inextricably intertwined. She has participated in several feminist and anti-racist organizations. During the late 1960s and the 1970s, Faith Ringgold played an instrumental role in the organization of protests and actions against museums that had neglected the work of women and people of color. Her paintings from this period are overtly political and present an angry, critical reappraisal of the American dream glimpsed through the filter of race and gender relations. In her later works she provides young African Americans with positive role models.[47]

In 1995, Ringgold published her first autobiography, *We Flew over the Bridge*. The book is a memoir detailing her journey as an artist and life events, from her childhood in Harlem and Sugar Hill to her marriages and children, to her professional career and accomplishments as an artist.[48]

Conclusion

In this session, you were invited to look at three-dimensional artwork. You learned that all materials have a feel to them, just like colors. In the second exercise, if you would have painted your box (for example with the title "The Box of My Life") black, you would have given a different message to the viewer than if you would have painted it light pink. The same accounts for materials and compositions. If you would

have opened windows and created happy scenes inside the box, the message about your life is positive. If the box would be painted black and have no cutouts, the message is different! Learning to understand these sensitivities occurs automatically when you make art regularly and use self-reflective thinking, asking yourself questions and connecting images, feelings, colors, and metaphors to your answers in your imagination. You designed a 3-D artwork about your personal issue. You learned to start the process by thinking about your issue, asking yourself questions and writing down the answers in your artist's journal. Then you explored how you can translate the feelings and images that surface in your imagination into materials, colors, and composition. The next step was to design and make your artwork. You read Tina's comment about how she found the household glove by remembering her mother. Her imagination took her to her memories while she was thinking of her issue "Feelings of Women." You saw how Markella made "angry paper" by throwing a lot of black cardboard and pictures into the mixer.

Homework

Check out the quilts done by Faith Ringgold on the Internet. As you will see, she uses the idea of narrative. Each quilt has a specific focus, a specific narrative that is important to her. What do you think of the work of Faith Ringgold? What do you think about her approach? Is there any element from your cultural heritage or artistic traditions that could inspire you for your own work? What is the narrative, the story of your life? In what way have you been active in your community for a cause or injustice, or would you like to play a role? Have you thought about how this could blend in with your art making? Write about this in your artist's journal. Take your time to finish your own 3-D or new materials artwork; if you cannot finish it this week, there is always next week!

Session 9
Abstract Art

Abstract art has very much to do with how the artwork communicates with the viewer, with how it feels. Because you have ventured into how to express this during the past sessions, it might be easier than you think to make an abstract collage or painting while you focus on how your issue feels. Look again at the list of feelings to find that specific feeling that fits with your issue. The basic ingredients of abstract art are lines, shapes and colors. Abstract art feels very basic, very primal; it's a great way to express how you feel about the issue you are working on. Choose shapes and colors; add lines if you want to give your artwork a feel of direction or make it dynamic. Do some self-reflective thinking and ask yourself questions. If your issue is freedom, and it was an abstract collage or painting, what would it look like? "What do I feel when I think of the word *freedom*? What are the colors, shapes, and lines of freedom for me? What kind of freedom is my freedom? Is it a lot of Freedom, or just a little freedom? Is it joyful freedom or bitter freedom? What do I see in front of my inner eye, my imagination, when I ask myself those questions? Which colors do I see? Which kinds of shapes (large or small) express my feelings about my issue in an abstract way? What does an abstract composition of freedom look like?"

Experiment with shapes until you find those that match your feelings. There are geometrical, amorphous, and natural shapes. You can fill all the paper or leave some space blank on purpose. Think about the meaning of the blank space. Remember that contrast creates tension and that successive layers of shapes give depth. How could you use your own abstract language in expressing what you feel about the issue you are working on?

In this session, you will combine all the previous sessions. What shapes do you see or sense when you describe the issue you are working on? Which colors pop up in your mind? How can you give shape and color to the feelings you have about your issue? Soft, sweet feelings or strong, intense feelings? Small, hardly noticeable feelings or huge feelings that undermine you? How could you use repetition, direction, or size to express how you feel about your issue? The abstract expressionists explored the meaning and expressiveness of shapes in relation to emotion. Maybe you remember Lee Krasner's collages, in which she uses knifelike shapes for her anger and jealousy. Krasner was intimately involved in the synthesis of abstract form and psychological content.

Exercise 1

Start with creating shapes (squares, triangles, circles, etc.) of various colors. Cut them out of paper with scissors or paint them. Experiment playing with small and large, light and dark shapes, in order to create an engaging composition.

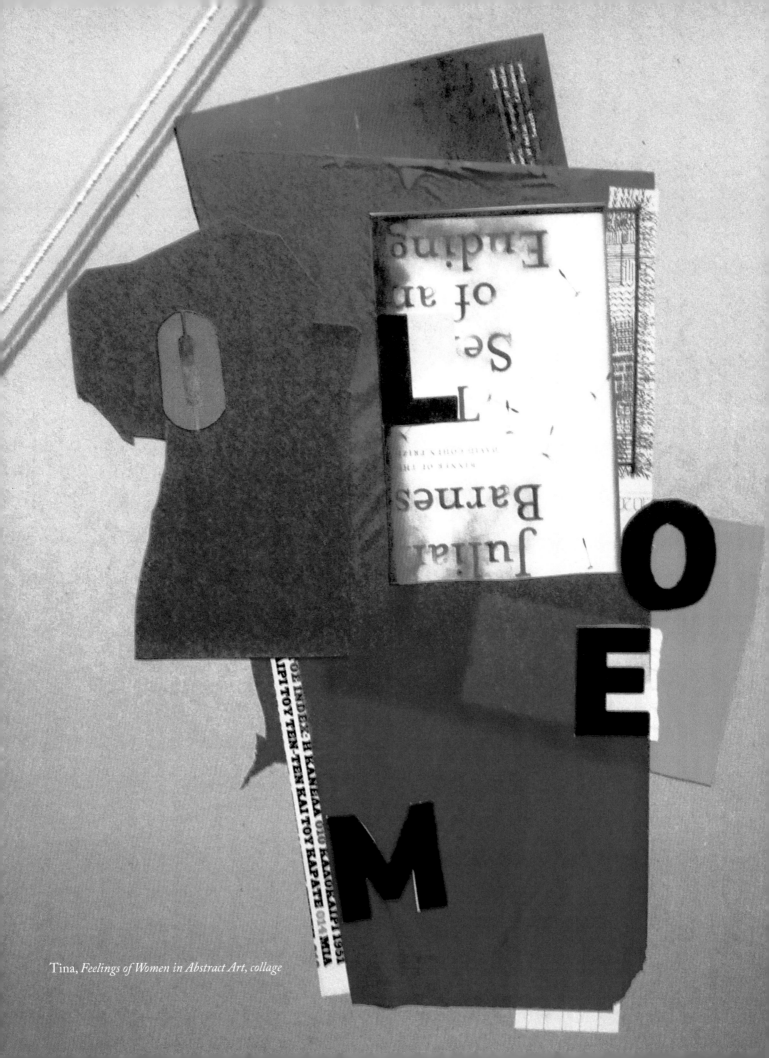

Tina, *Feelings of Women in Abstract Art*, collage

Exercise 2

You might try out painting in an abstract way, even if you have never painted in your life. You may work on your table with paints and brushes, but you may also try to find a wall in a place that is easy to clean; maybe in your bathroom. Even the floor of the garage is a perfect place to use for trying out abstract painting! Stick a piece of paper as big as you like to the wall or floor with large paper tape; it is easy to remove your artwork afterward without damaging the surface. Buy cheap paint, use an old tray for serving coffee, and paint with brushes (or with your hands). If you want to keep your hands clean, buy medical gloves. Experience how it feels to create shapes, lines, or colored surfaces with your hands or your brushes.

Assignment

Make an abstract work of art based on your issue of personal interest using collage techniques or painting. Focus on how it feels. Think about the colors, the lines and the shapes. Look again at the exercises you did for Session 6, maybe you can use what you learned there. Experiment first until you feel you are on to something. Maybe you like painting better than collage, like Markella. Feel free and enjoy the process! Even if it is a difficult issue like fear, it is liberating to freely express it. Markella found black and red were her colors for anger, and she created a gridlike composition with horizontal and vertical lines to give expression to the absoluteness of anger. She said, "You either are or are not angry."

Markella, *Anger in Abstract Art*, acrylic paint

Annette's Journal

I had my interview with Tina before the session. She said her thinking had become deeper because of dealing with one theme for a few months. In this session, Tina explored round shapes with a carbon drawn line. Then she abandoned that and started to make a composition with big and small pieces. She worked till the last minute of the session. I saw her thinking about adding parts: she would step back, change things, and step back again. Tina likes to work away from the big table where everybody is working. She puts a small table at the side or even puts her work on a chair. She always works standing up and doesn't talk so much anymore. She works while remaining concentrated.

Anna took her abstract painting home, and when I asked her to make a picture, she said she'd thrown it away. She said she felt very uncomfortable with abstract art; it wasn't her thing. She tried, and she understood she didn't like it.

> That session was very hard for me—the abstract collage. With the colors, it challenged me. I even thought about it again this morning. I did it, and I will show you, but it resulted in some emotional impulsivity, I don't want it. I did it, but I want to put it aside. I want to make another. I want to see how the next one will be. I personally get mixed up when I see a big artist, and I say, Wow! Like Miro or Matisse, I get mixed up, and unconsciously I try to do something alike. I have to put it aside, or to bring it at the same level with myself, because usually a big artist—I feel he is on top of me, and it influences me very much, and I cannot make anything. I feel intimidated. Matisse … I admire him a lot. It influences me. I have read and seen so much, it influences me, it influences my soul. I don't know if other people have that too.
> —Anna

Markella had made about three collages at home. All were based on the color red or variations of red (bordeaux, fuchsia), but in one collage she used cobalt blue in combination with red. On the cobalt blue, she had stamped red triangles with a potato stamp. In the center of the collage were three very angry faces. She likes mixed media; that's her thing. She did a collage about a central figure who was all wrapped in rope. The rope went all around the carton board—a very strong image. She was quite noisy today, happy, chatting, and making fun, but she worked so hard! She explored shapes and colors in a composition, keeping in mind the principles of art and design. She dares to try out new combinations now in contrast to the beginning of the workshop as I reinforce this again and again. I guess giving students a method and assuring them that it is going to bring desired results helps them to relax and explore things. I have to tell them every session, "Play, explore, try things out. It is okay. You are exploring your process of becoming an artist. That takes a lot of time. You are not supposed to come

here and make a finished work of art every week that is very good, artistic, and amazing. You are supposed to explore what it feels like, what it looks like, which colors feel right, and stuff like that."

Markella likes this kind of support. She needs a lot of assurance that what she is doing is "good". She has an amazing production in contrast to when we started the sessions. I told her she has started to delve into her theme from all possible sides and that slowly she will go deeper, and more specific ideas and images will come. It is like opening doors. She liked that. Other students stop themselves too when they are trying out something new. Apparently, this produces a lot of anxiety. In the case of Markella, because she liked to do what the teacher said, she did go out of her comfort zone and thus made important discoveries about the magic of colors and shapes, which helped her a lot in her quest to visually investigate anger.

Artist Related to This Session:
Joan Mitchell (1925–1992)

Abstract expressionist artist Joan Mitchell[49] is known for the compositional rhythms, bold coloration, and sweeping gestural brushstrokes of her large and often multipaneled paintings. Inspired by landscape, nature, and poetry, her intent was never to create a recognizable image but to convey emotions. Joan painted "landscapes she remembered," blue being related to Lake Michigan, green to the fields, and white to fear, the color she used to conceal and take away the other colors. Fear (white) was the color that was in control of her compositions.

Joan Mitchell was born in Chicago. After graduating from the School of the Art Institute of Chicago in 1947, she was awarded a James Nelson Raymond Foreign Traveling Fellowship, which took her to France for a year in 1948–49, and it was there that her paintings moved toward abstraction. In her early years as a painter, she was influenced by Paul Cézanne, Wassily Kandinsky, Claude Monet, Vincent van Gogh, and Henri Matisse, and later by the works of Franz Kline and Willem de Kooning.

In 1955 she began dividing her time between New York and France, and in 1968 she settled in Vétheuil, a small town in the countryside outside of Paris, where she worked continuously until her death in 1992. The artist herself referred to the work created in the period of the early 1960s as "very violent and angry," but by 1964 she was "trying to get out of a violent phase and into something else."

According to art historian Linda Nochlin,

> the meaning and emotional intensity of Mitchell's pictures are produced
> structurally, as it were, by a whole series of oppositions: dense versus transparent
> strokes; gridded structure versus more chaotic, ad hoc construction; weight on

the bottom of the canvas versus weight at the top; light versus dark; choppy versus continuous strokes; harmonious and clashing juxtapositions of hue—all are potent signs of meaning and feeling.[50]

Mitchell was very influenced by her feelings and incorporated it into her artwork.

Mitchell's uncompromising personality has been a key factor in interpretations of her painting, which critics often read as expressions of rage and violence. Yet almost as often, they have seen lyricism in her work. Mitchell gave personal support to many young artists who came to stay with her at Vétheuil—sometimes for just one night; sometimes for an entire summer. Correspondence in her papers reveals that this generosity often had a life-changing impact on those that spent time with her. Her generosity in her own lifetime continued after her death with the formation of the Joan Mitchell Foundation, called for in her will in order to create support and recognition for individual artists.

Conclusion

In this session, you researched abstract art. You learned that abstract art has its own language: the language of sensing and feeling. You ventured into finding your own abstract vocabulary, finding exactly those shapes and colors that fit the feeling you want to communicate about the personal issue on which you are working. Maybe you even experienced the joy of non-figurative art making, creating your very own personal tiny shapes for tiny feelings and huge shapes for big feelings, zooming into the way you feel color behind certain feelings. You experimented with painting how your personal issue feels. You also made your own abstract work of art, guided by translating your narrative, your story about your personal issue into shapes, colors, and lines. You were introduced to Joan Mitchell, who painted "landscapes she remembered" and landscapes that had become "inner landscapes" because they were landscapes of what she remembered and how she felt about them. She painted landscapes of the feelings she remembered when remembering them, or landscapes of her own feelings of worry, fear, and anger as she painted them.

Homework

Reflect on your experiences concerning this session in your artist's journal. What did you like? What didn't you like? Take a step back and reflect on your process. Ask yourself the questions you learned, "Where did I start? Where did I get stuck? How did I solve it, and what did I learn?" If you feel like it, check out Joan Mitchell's work on the Internet. You may also check out the classical abstract artists (Paul Klee, Joan Miro, Jean Arp, and Wassily Kandinsky) or the abstract expressionist artists and describe in your art journal what you think about their work. There are also some very inspiring YouTube videos you can watch. Finish your abstract artwork this week.

Session 10
Mixed Media

Mixed media is a kind of fusion of materials; you may use and combine whatever media appeals to you. The possibilities are endless. A principle aspect of mixed media artwork is layering. You may combine painting, collage, photomontage, pencil, ink, printed material, plastic, or cardboard. You can also go further and use previously self-made paper or add shells, old stockings, beads, wire, string, pieces of leather, aluminum foil, wallpaper, lace, feathers, cloth, fake jewelry, newspapers, nails, or wood. If you'd like to use paint in combination with these objects, synthetic polymer paint is a better option than plain acrylics. There is never a "best" solution. Simply by exploring and trying out different materials, you will discover what works best for you. This also counts for finding the right glue for mixed media. Some people prefer wood glue, some love liquid cement, and others work only with a glue gun. If you want to try out using more heavy objects, plywood is probably the best basis on which to work.

Mixed media is a fun way to explore how visual material can be symbolic. Photographs ("clear pictures") could symbolize things that are clear, whereas cut or torn colored paper could symbolize uncertain situations or some feelings or thoughts that are not clear. Shapes could reflect some aspects (thoughts, feelings, impressions) about the intuitive inner monologue of the artist. These shapes can become even more fluid (liquid) if made with paint, in a manner made completely by accident: sloshing and splashing the paint on the paper. In this way, the artwork gets a spontaneous or primal feel as well. Small objects like rings or safety pins have their own symbolic value.

What would a mixed-media artwork that focuses on visualizing "My Inner Landscape," "Nurturing," or "Anger" look like? Use your imagination to find what kinds of materials you could use for your issue, as well as which symbols and personal metaphors. Imagine it is "Happiness." Break this large concept down to details using Socratic questioning: What does happiness make me think of? What image do I see in front of my inner eye when I say *happiness*? What is the most important aspect of happiness for me? Which materials and shapes do I connect with happiness? Which objects, images, photographs, and colors could I combine to express happiness in my artwork?" Questions help you zoom in on what is particularly important to you and then help you visualize it.

A classical example from the history of art is the work of Robert Rauschenberg. His "combines" are perfect illustrations of mixed-media art. Rauschenberg used found paper and found objects to bridge the gap between art and life and to express what he called his "inner monologue." He also wanted all the elements in his work, like the painted areas and random pieces of paper, pictures, and objects, to have the same importance, and he did this by focusing on the communication between the elements in his artwork. That communication had to do with how a blot of paint felt and how it felt to combine it with, for instance, a picture, an object, or a line.

Tina, *Feelings of Women*, mixed media

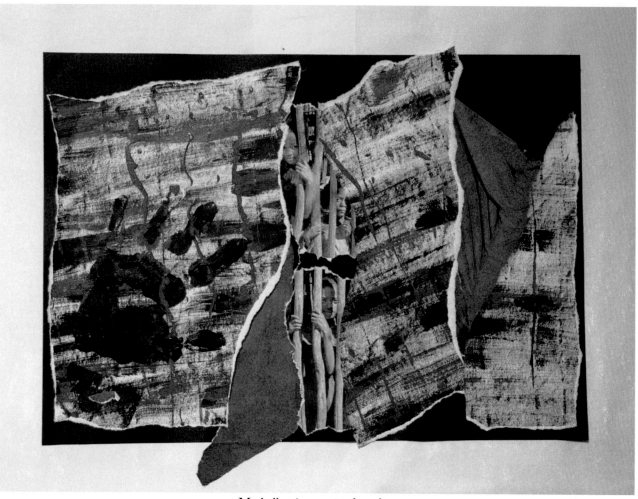

Markella, *Anger*, mixed media

Exercise 1

Mark making is seen often in mixed-media art. Try making some stamps from potatoes or corks, or make marks on paper or cardboard dipping all kinds of objects in acrylic paint. You could even take a large piece of polyester insulation foam, or the kind used in packing TVs. Dip it into paint and press it repeatedly onto the cardboard or plywood to create a surface that looks like printed. Play around to get ideas. If you have no clue on how to make stamps, do some research on YouTube. There are many very handy short videos about how to make potato or cork stamps.

Exercise 2

Browse through some magazines and cut out large photographs of faces of people. Use acrylic paints to paint over the photographs, changing these portraits into characters from a story. Paint mustaches, make funny hair, or add glasses, a collar, different clothes, or masks. Enjoy it!

Assignment

Choose colors that relate to your issue and start playing - splash paint on paper, or make lines and shapes. Let it dry and then cut out various colored shapes from that painted surface, big and small; use symbolic shapes that you think suit your issue. Use them in a collage together with other elements that fit your composition, like pieces of cardboard, photos, self-made paper, etc. Whatever feels right! While creating your mixed-media artwork about your personal issue, you may complement your artwork with paint if you feel like it.

Annette's Journal

I explained that apart from abstract collage and photomontage, they could work in mixed media. I told them about Rauschenberg and how he wanted paint and meaningless pieces of found paper to have the same importance, the same weight in an artwork as a picture; he did this by focusing on the communication between the elements in his artwork. I told them to play with paint, use the colors that relate to their theme, make lines and shapes, let them dry, and then cut out the colored shapes they liked and use them in a collage with other elements, like pieces of cardboard or photographic material.

Tina had brought her foam material and made a composition with photos of women's bodies and square shapes from self-made grayish paper and some paint. After the big red one, she went back to her well-known style. The change is that she now works on bigger surfaces and prefers the foam sheet. Markella had an incredible breakthrough. On blue carton, she worked with photos and enlarged photo material and cardboard, and she made a big, elaborate collage on "blue anger". Anna made an interesting shape in paint, and stuck pieces of paper on it. She then added more paint, and then when she realized she did something new and wonderful, she started thinking about it—and then she stopped! But she had the breakthrough, and although she always sits down and cuts something and finishes it at home, this time she was standing up the whole time, trying to see if it was better on black or on white carton. She took it home to work on it in Photoshop.

I asked Anna during the interview about her art.

When did you start combining Photoshop with collage?
Many years ago. I discovered Photoshop myself. I taught myself photography, and I discovered collage myself. Three different things. You let me combine photography, Photoshop, and collage, whereas others said, "What you do isn't Photoshop, isn't collage, isn't photography."

But that was so artistic, that you found a new way, your own way.

Sometimes people ask me, "What are you doing?" I don't want to find words for what I'm doing. I do what I do, and if I find a name for what I'm doing, I will find it later. I cannot give it a name.

It's mixed media.

Yes that's it.

Anna, *What Is Under the Shadow?* Photomontage and Photoshop

Artist Related to This Session:
Ellen Gallagher (1965–)

Ellen Gallagher brings together imagery from myth, nature, art and social history to create complex works in a wide variety of media including painting, drawing, relief, collage, print, sculpture, film and animation. Gallagher's influences include the minimalist paintings of Agnes Martin and the repetitive writings of Gertrude Stein. Referred to as African American she is of biracial ethnicity; her father's heritage was from Cape Verde in Western Africa (but he was born in the United States), and her mother's background was Irish Catholic. Her (partly) black background has strongly influenced her work.

Gallagher's work explores identity and transformation, referencing historical and contemporary subjects that include modernist abstraction, marine biology and popular black culture. She makes repeated references to traditions of blackface and minstrelsy, as well as performers and musicians. Historically specific cultural references are merged with Gallagher's own personal biography.[51]

In her artwork she examines the development of African-American stereotypes. Gallagher incorporates pop culture ephemera into her work, particularly postwar-era advertisements for hairstyles, wigs, and skin products targeting African-American women. Initially, Gallagher was drawn to the wig advertisements because of their grid-like structure. Later, she realized that it was the accompanying language that attracted her, and she began to bring these "narratives" into her paintings—making them function through the characters of the advertisements, as a kind of chart of lost worlds. [52]

Gallagher studied writing at Oberlin College in Ohio. In 1992 she earned a degree in fine arts from the School of the Museum of Fine Arts in Boston and her art education continued in 1993 at the Skowhegan School of Painting and Sculpture in Maine. Gallagher has made innovative use of materials, such as creating a unique variation on scrimshaw (the 19th-century art in which whalers carved animal bones to create tools and pictures) by carving images into the surface of thick sheets of watercolor paper and drawing with ink, watercolor, and pencil. These works depict sea creatures of the mythical undersea world of Drexciya, which were the progeny of slaves who had drowned. She participated with this series of works at the Venice Biennale in 2015. Gallagher's mysterious vision of marine life extends beyond the canvas and into other media, such as the 16mm film installation *Murmur* (a collaboration with Edgar Cleijne), as well as the ongoing series of delicate watercolors and cut paper works entitled *Watery Ecstatic*. Gallagher has studios in New York and Rotterdam (The Netherlands).

> There's so much happenstance, so many accidents—stumbling into something and finding it interesting and living with it over time and building on it. It's okay to work from doubt. You need to be willing to not know.[53]

Conclusion

In this session, you learned about mixed media. You learned that layering is an important principle for mixed-media compositions. When working with a specific issue and using the method "visualizing images behind words," you may find specific colors, materials, and objects that fit precisely with what you want to express about your issue. Using plywood as a background will give you a lot of freedom attaching whatever small object you'd like to your artwork. Mixed media has many possibilities. It combines the freedom of abstract art with the preciseness of photomontage, and you can add some oomph by using three-dimensional objects from the real world like beans, stones, rings, pieces of wood, string, or wire. Mixed media offers many options to visualize and materialize the inner monologue that is going on in your head. Think in layers. The background could be your general feeling about your issue. How could you choose the various materials to express your issue visually in your own individual way? You will realize that mixed media is a very liberating way of working!

Homework

Do some research on the Internet on the artist Ellen Gallagher. What do you think about the narratives that accompany her work? Does it inspire you to expand your own narrative and context of your personal issue by doing research? You can do research in order to increase your knowledge or awareness about your issue by looking into what scientists, philosophers, historians, psychologists, politicians, activists, writers, and journalists might have written about it. Are there any novels, poems, films, or songs you can find? You might find some really interesting material that can deepen your visual expression. If you haven't finished your mixed media artwork, try to work on it a bit every day.

Session 11
Try Again or Experiment!

Until now, you worked from a different perspective in every session. You've chosen a personal issue, thought of some personal metaphors that have to do with it and the memories you have relating to it, learned about the psychology of color, looked at possible dreams or nightmares concerning your issue, and inspected the images and colors behind feelings having to do with it. You looked at your position in life, what you believe in (spirituality), and its relationship with the issue you are working on. You experimented with composition and maybe tried out new materials or three-dimensional collage. Possibly you enjoyed translating your issue or theme into an abstract collage or painting. And you learned how you can combine all this information relating to the visual expression of your personal issue in a mixed-media artwork.

In this week's session, you are free to choose what appealed to you most from all these previous sessions and elaborate on that focus in the same way, or maybe you'd like to try out something different. You might work again in line with one of the previous sessions, or you might combine the angles of a few sessions, like finding metaphors for memories or dreams. You are completely free to do whatever you like for this session. Maybe you have been wanting to try out something completely new and original, and you felt you never had the time. This is a session where you can venture into exploring and going on a quest to figure out something by yourself. A lot of captivating art was created totally by accident or by doing some "off-road" experimenting with new materials, new compositions, or new ways of working. Give it a go!

Exercise 1

Let's go back to the issue you worked on these past ten weeks. Look at the images you wrote about during the first session, and let them inspire you to work on your issue from a different angle. How can these images inspire you or give you ideas to create a different artwork?

Exercise 2

Look at your ten artworks, made over the course of the past ten weeks. What did you discover? What did you discover about yourself? First, you worked on visualizing your narrative, your story about an issue about which you feel passionate. Now you will write about your art, the visual expression of your story, how it came about, and how you experienced making it. Describe your work in your own words! Write a

short text about your artistic process and what you discovered. This is called an artist statement. It is about the what, how, and why of your work, from your own perspective. What is your art about? How did you make it? What did you discover? The artist statement is the description of your artistic voice. It helps you convey the deeper meaning or purpose of your work to the viewers who will see it in your exhibition. Next week, you will learn how to organize your exhibition.

Markella, *Images, Shapes and Colors of Anger*, mixed media

Assignment

The assignment for this week has two options. You can work again in the line of your favorite session, making another artwork in that technique or using that focus. Maybe it was finding metaphors, diving into memories, or exploring colors and feelings. Maybe it was making an abstract painting or a mixed-media collage. Do some self-reflective writing in your artist's journal, following Socratic self-inquiry: "What did I like most, and why?" The other option is to try out something completely different. Explore and experiment and make new artistic discoveries. Maybe do some writing first in your artist's journal. Ask yourself, "What do I want to try out? What am I really curious about?" Then just do it!

Anna, *Feeling the Shadows*, Photo-shopped photomontage

Annette's Journal

We talked about the exhibition that we had planned for the next week. I told the women I wanted the exhibition to be a reflection of the diversity in the group, and I wanted everyone to do it as they liked—to choose their own framing and decide on how they would hang their work. There was a lot of resistance. Markella said there wasn't enough space to hang everything. I said the walls were very high, so they could hang up to three rows of collages. I claimed they should hang everything to show the process because the exhibition was called "Art as a Process." They said they couldn't hang the first ones or the bad ones because they were not "good," and it was a public exhibition. They also thought three rows would be too high; nobody would be able to see the top row. I realized it was a cultural thing, and I was maybe too theoretical or idealistic about the exhibition. Markella, Tina, and Anna were fierce. I sensed a lot of fear and tension because of the oncoming exhibition. Markella used phrases like "superficial," "not serious," and "we will make fools of ourselves."

It took me half an hour to calm everybody down. The women insisted they wanted a set format for everybody: the same background, the same framing, the same layout. I refused and said, "In art, you have a chance to escape the pressure of the mainstream and do your very own thing—but now you surrender to mainstream thinking, you surrender to the system? You all worked on your personal artistic development, and now you want me to exhibit everything in the same way? No. Everybody will exhibit her work in her own way. That's the spirit of this workshop." Eventually they reluctantly accepted. We talked about the practical side of the exhibition and the wines and nibbles, and we arranged to be at the gallery on Friday morning. Everyone was given a space in the gallery, a piece of wall measuring 3.5 meters (11 feet).

In this session, nearly all students worked with mixed-media techniques. They started with paint on paper, and when it was dry, they tore or cut the painted paper into pieces to use it in a collage. Tina made a composition called "Feeling Free," an ecstatic dancer jumping through veils and clouds (see p. 20). I talked to her about it.

How has this workshop fostered your artistic development?
A lot, because I had never done anything for myself till I started lessons with you. I only did my work. I liked my work, but it was not something that was mine. I liked your lessons very much. It helped me a lot. I am much calmer and peaceful. I am more content about my life. I think I make little steps, and I develop in my work. I understand more and more. Very much. It is a light in my life.

Markella also said making art in this way had changed her:

How has working on an issue of personal interest changed your work?

Yes, it has influenced me. I don't know if this is the right answer, in that because I have this issue in my mind, it works constantly in my mind, in strange moments. I go deeper. I search for things constantly. It helped me. I go deeper … I search constantly. I think about it constantly, and I think about other collages that I could make. I touch it more. There is more focus. I go to a deeper level. And I think about it constantly. I make it richer, and I think about other collages that I could make.

How did it change you?

Yes, that really happened. Certainly. I saw things in myself that I hadn't realized. This issue of mine, anger, that revealed itself inside me—it unlocked me in certain moments, in the traffic jams. I thought about the way we live, and I felt anger.

So that was new for you.

That was new. It was a way to do psychotherapy for me. Something like that. Psychotherapy. Analysis. Like in the theater, when you have a role that expresses you, yourself. You want to research yourself. I imagine it works the same way.

Artist Related to This Session: Nancy Spero (1926–2009)

Nancy Spero is known for her continuous engagement with contemporary political, social, and cultural concerns. Her radical career encompassed many significant visual and cultural movements, from conceptual art to postmodernism to feminism. Spero concentrated on the depiction of women: mythological women, movie women, tortured women. She made the female experience central to her art's formal and thematic development. She created a personal, figurative lexicon representing women from prehistory to the present. These female recognizable characters from history, mythology, and pop culture float, dance, and run through Spero's collages. She didn't hesitate to use sexual imagery to shock the viewer into recognizing the relationships between sex and power, war and obscenity. Spero culled her source material from books and media, which she integrated with her own invented imagery—transformations that inspire us to reimagine the world we inhabit.[54]

> The figures in my work are culled from ages and epochs, media and mind. Despite their diversity of origin, they are all women—coexisting in a compression of time and history to present a new voice.[55]

Nancy Spero lived for much of her life in New York City. As both an artist and an activist, Nancy

Spero had a career that spanned fifty years. She studied at the School of the Art Institute of Chicago, graduating in 1949. After her graduation from the Art Institute, Spero continued to study painting in Paris at the Ecole des Beaux-Arts and at the atelier of Andre Lhote, an early Cubist painter, teacher, and critic. Soon after her return to the United States in 1950, she married the painter Leon Golub, and the two artists settled in Chicago. From 1956 to 1957, Spero and Golub lived and painted in Italy while raising their two sons. In Florence and Ischia, Spero became intrigued by the format, style, and mood of Etruscan and Roman frescoes and sarcophagi that would influence her later work. Finding a more varied, inclusive, and international atmosphere in Europe than in the New York art world of the time, Spero and her family moved to Paris, living there from 1959 to 1964. Spero's third son was born in Paris, and the artist had major solo exhibitions in Paris at Galerie Breteau in 1962, 1964, and 1968. Spero and Golub returned to New York in 1964, where the couple remained to live and work.

An activist and early feminist, Spero was a member of the Art Workers Coalition (1968–69) and the Women Artists in Revolution (1969), and in 1972 she was a founding member of the first women's cooperative gallery, Artists in Residence (AIR) in SoHo. It was during this period that Spero completed her Artaud Paintings (1969–70), finding her artistic voice and developing her signature scroll paintings: Codex Artaud (1971–1972), based on the texts of the French writer Antonin Artaud, whom Spero described as the "most extreme writer of the 20th Century." In reading Artaud, Spero coined the term "victimage," making a parallel between Artaud's language and her feeling of the "loss of tongue" as a female artist in a male-dominated art world. One of Spero's great inventions was the fracturing of text and image in the Codex Artaud works, which some critics have described as the first works of postmodernism. Uniting text and image, printed on long scrolls of paper, glued end to end, and tacked on the walls of AIR, Spero violated the formal presentation, choice of valued medium, and scale of framed paintings.[56]

Conclusion

In this session, you were invited to choose your favorite session and work again in that style. Or if you felt like trying out something new and different, you could go on a quest and explore new ways in your art making or in using materials. In exercise 1, you looked again at the images you found at the start of the workshop and you worked on your issue from a different angle. In exercise 2, you practiced writing a short text about your art, called an artist statement; it helped you uncover and verbalize the what, how, and why of your work, from your own perspective. If you want, you can print this text for your exhibition so that the audience that comes to see your work can be informed about your original idea, artistic process, and discoveries. The assignment helped you link self-reflective writing about your artistic work with planning and envisioning a new artwork. In "Annette's Journal," you read about the stress and discomfort your three classmates sensed in regard to preparing their exhibition. It is quite a step to exhibit your

work and share it with others, but the rewards are support, admiration, and useful feedback. Making art and showing it to the world are important for your empowerment and personal growth; it helps you to become conscious about who you really are. In this session, you were introduced to Nancy Spero, a pioneer in feminist art whose work confronts social and political injustice with creative ingenuity. She expressed her outrage and anger about sexism, injustice, and war not only in her art but also by joining several activist groups including the Art Workers Coalition and Women Artists in Revolution (WAR). Her work is innovative, wide-ranging, feminist, anarchic in spirit, and tenaciously political. She was a very unconventional artist and did not paint with oil on canvas. She worked exclusively on paper with pen and pencil, ink and gouache, stencil and collage. She used all sizes of paper, even large paper scrolls, which would hang down from the ceiling in rows.

Homework

Do some research on Nancy Spero's life, artistic choices, and artist statement. Look at her art on the Internet. What do you think about her subject matter and research? What do you think about her art? How can her work inspire your way of working? Also, please finish your artwork this week!

Session 12
Preparing Your Exhibition

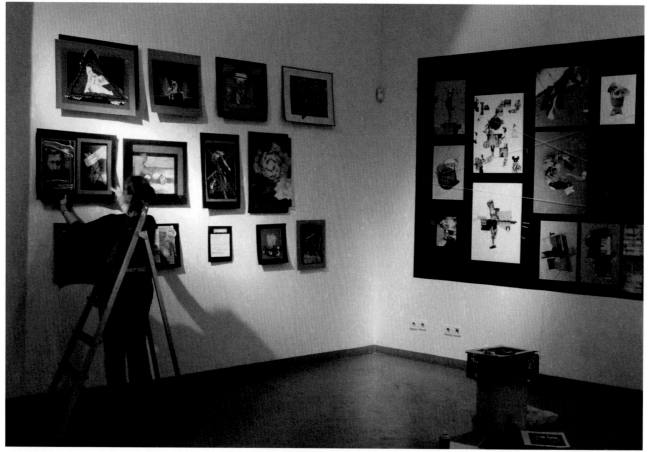
Setting Up the Exhibition

The three months during which you worked on discovering your artistic voice are over. You have learned much and made new discoveries about your art making, about what you like or not, and about who you are. You have discovered many new things about the way you look at the world and at life, as well as about the way you experience your life. Now, the time has come to share this personal artistic perspective on life with friends or neighbors. This will give you support, admiration, and useful feedback—a good point from which to continue in your artistic and personal development from now on!

It is a lot of fun to curate your own exhibition. Maybe you'd like to hand out invitations or design your own poster. You can organize your exhibition at your house, at a friend's house, or maybe in a community center. Curating your own exhibition means you can hang the artworks you have made over the past twelve weeks exactly the way you want. You can hang them, or you can display them on a table or on some tables. Whether they are next to each other or on top of each other, you decide. Next you will spend time

choosing them, framing them (or not), preparing the information about each artwork on little tags, and (if you wish) writing an artist statement about the process you went through. Realizing in hindsight what has happened and what you have learned and understood is just as important for becoming conscious of your artistic voice as making all the discoveries. It means embedding the new insights and making connections with the knowledge that you obtained earlier in your life.

You can photocopy the following text if you'd like to explain to your visitors that they are going to see the exhibition of someone who has worked on discovering her artistic voice and, to that purpose, activated her inner world, dived deep inside herself, zoomed into her memories, dreams, feelings, cultural background, and beliefs, explored color and personal metaphors, and distilled images from these areas of her mind that were the basis of her artwork. The more information you provide and the clearer it is to the viewer, the more interesting feedback you will get from the visitors of your exhibition. They will understand it is not a plain art exhibition but a series of works reflecting the quest for discovering artistic voice.

This art exhibition is the result of my devoted work for twelve weeks on an issue of personal interest. The ultimate goal of this twelve-week period was the development of my artistic voice. I wanted to learn how to get close to my unique artistic style, discover my way, understand where I get inspiration from, discover what materials and techniques I like, and realize what personal life experiences are brimming with energy and longing to be expressed. I wanted to discover the color palette that is distinctly mine. In brief, I wanted to see who I was as an artist. I wanted to develop that one consistent artistic style that is mine alone and through which I could totally express what I want to say in my art.

With the help of twelve focused creative assignments that encouraged introspection and stimulated my imagination and creativity, I visually explored this issue of personal interest. The focus was on the art process and discovering, not on the end result.

I visualized many facets of my chosen issue. By seeing images behind the words I used to describe it, I found what connects me to it. I explored the relations between colors and feelings and researched the language of shapes. I learned about how to find metaphors and use them in my art, as well as how to connect to my memories, dreams, and nightmares by making them alive in my imagination

and using their visual information for my art. I researched my spirituality and my beliefs about life, visually. I learned about the power of composition and how to use the visual language of color, shapes, and images to make a strong statement.

I used an artist's journal with blank pages that helped me reflect on the process and write about thoughts and ideas through the week. It helped me establish a connection with my inner monologue and start an inner dialogue about my art-making process. I investigated my issue by making inquisitive collages to try out combinations of images to visualize my thoughts and ideas. The collages exhibited here are the crystallizations of this artistic process.

Apart from this general text, you can use the artist statement you wrote in week 11 (exercise 2). That artist statement explained your choice of personal issue and how your visualizing process came along. Just a recap: Look at your eleven artworks made over the course of the past eleven weeks. What did you discover? What did you discover about yourself? First, you worked on visualizing your narrative, your story about an issue of personal interest. Now, write about your art, the visual expression of your story, how it came about, and how you experienced making it. Describe your work in your own words. Write a short text about your artistic process and what you discovered. Explain the what, how, and why of your work from your own perspective. In this way, you can convey the deeper meaning or purpose of your work to the viewers who will see it in your exhibition.

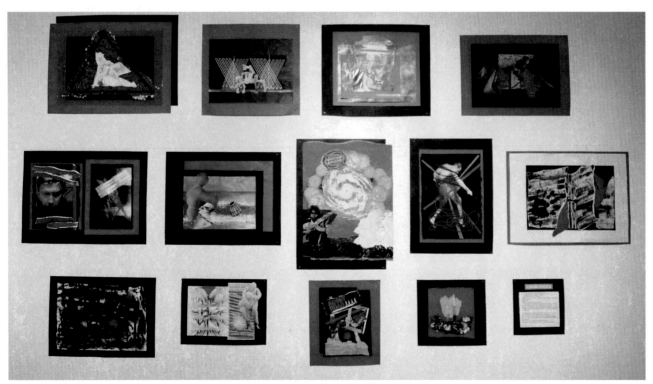

Markella's Artwork in the Exhibition

Here is Markella's statement to give you an idea of an original, authentic way to do it.

Anger … What a statement! The revolution of the ego.

The feeling of the caged wild animal.

Anger is full of animal power.

A cauldron throwing vapor, a stormy sea, a volcano, a nuclear explosion.

What color does it have? What shape could you give it?

Its shape is sharp, its colors are red like blood and black, dark as it comes from the foundations of being.

Blind, suppressed, strangled, distorted, political anger, social anger, revolutionary anger, demanding, anger plaguing the soul of man.

The problem I faced from the beginning of this workshop was to be able to function without thinking, to express myself, like our teacher said "with color and shape." Slowly, slowly I made some steps toward expression and cowardly toward abstraction. I think I have a long road to go. For the time being, I enjoy my newly acquired freedom …

Annette's Journal

The day of the preparation of the exhibition, I was a bit upset that they hadn't brought all their work; artwork they considered "childish" or "not good" was not included. Both Markella and Anna had destroyed some artworks. They said they didn't like them, and they wouldn't have fitted in the exhibition anyway. Only Markella had written an artist statement, and she attached it to the wall, next to her artworks.

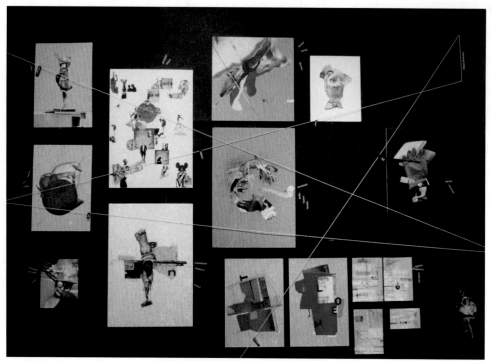
Tina's Artwork in the Exhibition

Tina brought a huge surface of black cardboard, hung her work on it the way she wanted it, and then "tied" her personal exhibition with string! Instead of an artist statement, she decorated her work with words supporting the meaning of it. Next to her collage *Freedom*, she wrote, "Power, poetry, harmony." Next to her mixed-media artwork *Feelings of Women* was, "Revolution, reversal, crevice." She didn't want to write an artist statement for the exhibition, and neither did Anna.

Tina, how has working on an issue of personal interest changed your work?
That is a difficult question to answer because I had the theme of women on my mind for a long time. It was nudging me for a long time. Women were present in my work but I had no men. There are no men in my collages! And that is not new, that has always been the case. So it was on my mind, and this was an opportunity to go for it, to give it all my attention. I will give all my attention to women. I wanted to work on that theme. That will not go on forever, I suppose.

And did it have any relation to the position of women in society? To injustice, maybe?
Maybe that was the reason for me as well. Or the way the others treat me. Well, my husband always said, "I don't want anybody to treat you in a way you do not deserve." I try to treat people in a proper way, and I want to be treated that way. But I think women in society have to do so very many things! An incredible load, and maybe that's why I'm interested in women. I feel they are so loaded: they are mother, lover, wife, professional, child, she has to be responsible for the friends, and when is she a woman, I ask you... It's not the fault of the men, I don't know why they are so loaded.

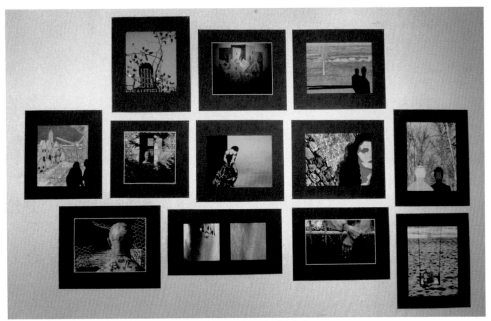

Anna's Artwork in the Exhibition

Markella put each of her collages on an individual red or black cardboard frame. Anna chose the same black cardboard passe-partout for all her work. Eventually they were happy with the exhibition, and they did agree that it was nice that each had chosen a different lay out. Because they were seven, there was not enough space to hang everything in one row, but it was not really bothering them. Our exhibition was a great success, and everybody agreed how interesting it was to stand in front of their artworks and answer questions from visitors.

Conclusion

In this session, you prepared everything for your personal exhibition. Maybe you designed and printed invitations or a poster. You thought about the presentation of your artwork, the tags with the titles, and the lemonade and the cookies. I hope you enjoyed showing your work to your friends and family!

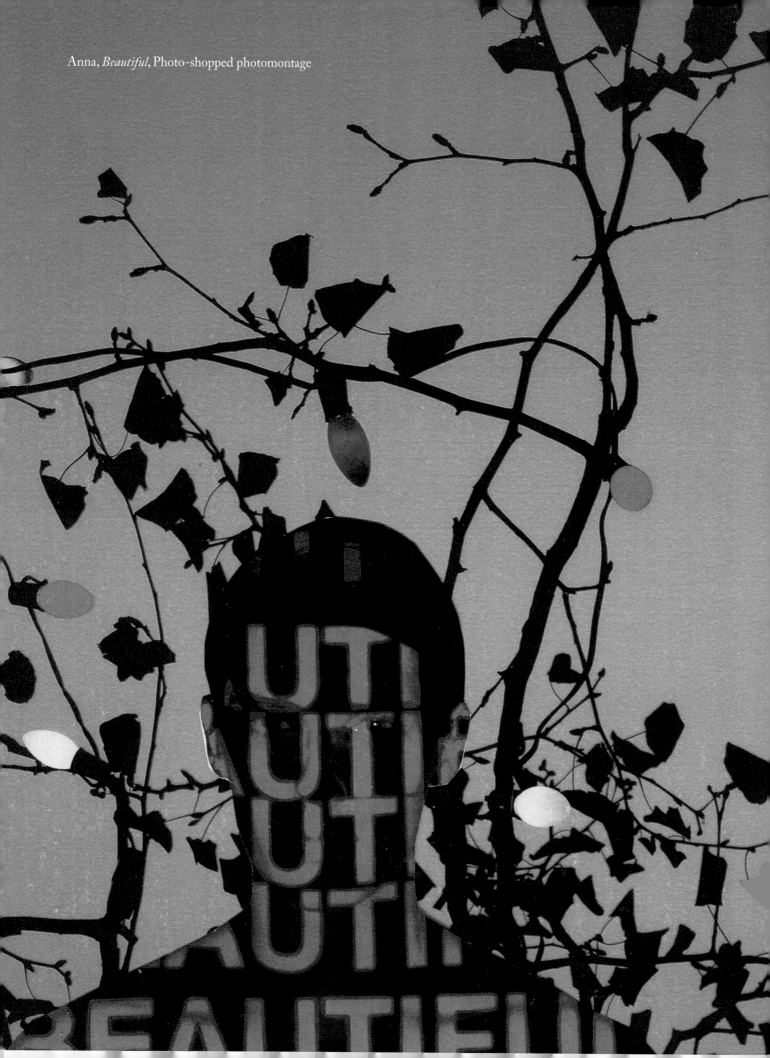

Anna, *Beautiful*, Photo-shopped photomontage

6. To Conclude

Yes, I think my way of thinking has developed more. And I go deeper, not superficial, when I search deeper, for ways to create the image I want. —Tina

The workshop "Becoming an Artist" had been designed to help my students find ways to make their own art. I wanted them to connect the multiple facets of themselves with their art making so that they would start to see, feel, and understand the connection between the artwork they were making and themselves. They needed to start looking inside themselves for inspiration and find their own ways to solve their art problems. Based on my own development as an artist, I developed a twelve-week collage art workshop to guide my students in their own process of becoming artists, with new teaching strategies that would activate their inner worlds.

The workshop wanted to give these women the opportunity to discover the personal stories they have to tell, as well as the tools to explore and express their narratives visually in their own way. I reckoned that if they would start to explore their inner worlds, the ways they experience life, then they would understand how precious, rich, and valuable their own life experiences are as material for inspired personal works of art, made with their own ideas, memories, colors, dreams, and feelings. They would go through the process of becoming artists and enjoy discovering and expressing who they are and what they have to say in their own ways. Except for their own life experiences, they needed the tools and skills to use these life experiences as inspiration to become artists. That was what this workshop was about.

Reflection and Exploration

During the workshop, I monitored the possible development of artistic ability by looking at the unfolding of imaginative thinking and the increase in creative skill in using materials and executing artwork. I meticulously followed three women over those twelve weeks. I wrote down my impressions of how they worked during the sessions and of developments in their artwork, and I posed self-reflective questions to them during an interview at the end of the workshop.

I took the role of a mentor. I clarified what it means to be an artist and how to connect with one's artistic voice: making the connection between the inner world (the self) and the outer world using the tool of the imagination.

I taught them the road to enter the imagination: the link between thought and imagination means visualizing images behind words. The women slowly understood they had to take active roles. They had to spontaneously find an issue that interested them personally, research what they thought and felt about their issue, write about it, and then search for personal images behind their words. They had to think (visualize) about ways to make their artwork. They slowly realized that they could even develop their own art-making skills. In the beginning some of them still said to me, "Tell me how I should do this. What is the way in art to do this?" At the end of the workshop, they understood how much fun it is to try things out and see for themselves whether it works. They started to use the tools to enter their imagination and visually express their ideas.

> In the beginning, it was difficult for me. Now I let myself. The process has become easier for me. I was searching; essentially, I was searching for my own path. That's why these lessons you are doing now helped me. Because they revealed my way of thinking, my feeling, my path, to me.
> —Anna

During the workshop's twelve weeks, a lot of invisible work happened in the minds of the women. The process of becoming an artist strongly resembles the development of a tulip bulb. When put in the earth, for about three weeks nothing seems to happen. But a lot of work is being done inside the earth: roots are being formed to collect moisture and food. The women had to understand first how to find images and colors, and how to visualize feelings. They had to become sensitized to associative and metaphorical thinking. A lot of work had to be done inside them! In the case of the tulip bulb, when the preparatory work inside the darkness of the earth is done, a tiny green stem starts to grow toward the light, and finally a bright green spot appears on the surface of the earth. This recalls the twelve-week artistic development my students went through. The increased cognitive and imaginative activity resembles the tulip bulb's invisible preparation under the earth. Imagine that they could have worked for a longer stretch of time. Students in bloom!

> I am forced to think of it the whole week. I have it in my head, and I cannot let go of it; it is a project. It is not like before, where you make something and you leave it, and next time you make something else. Now you have it in your mind. It is a project; it goes on in your head even if you don't work.
> —Tina

Connecting to the way they experienced life on the inside was hard: in the beginning of the twelve-week course, women had difficulty getting started with an idea for an artwork. It was especially difficult for them to generate images that had to do with their chosen theme. Using the mind to enter the imagination was something they were not used to doing. They needed to make the connection in their consciousness and in their thinking process, between words they used and what the world behind those words looked like for them.

128 Annette Luyex

There was resistance and hesitation in many students in the group at the beginning of the workshop.

> She moved restless in her chair, her body in turmoil. … The red color, the
> girl with the knives … she didn't like it anymore and searched the whole
> week for other images that would express anger but were not too obvious.
> —My observation of Markella, session four

As the workshop advanced, the fact that each session focused on one aspect of the artistic process influenced students' ability for deeper imaginative thinking and they found greater ease in producing original ideas. It was like they started to trust their own process. Fear made way for the excitement of discovery.

After twelve weeks, it was clear that the assignment prompts were effective in guiding the women to find images behind the words they initially used to describe their chosen issues. The reflective process resulted in rich imagery related to their inner world. Providing students with a specific focus helped them to concentrate on a segment of the personal issue they were investigating. It caused continuous self-reflection and consequently discovery of their narrative of self because they were deeply involved with their issue of personal interest. It also instigated emotional self-awareness through the increased ability to express feelings related to their issue in a visual way. Once the connection between thinking and seeing is established, the whole person is activated. A lot of new connections were established in the minds of the women. They discovered there was a vast world where thinking, seeing, feeling, intuiting, and being were integrated and functioning as a symphonic orchestra that was their unique sense of experiencing and living their lives. They started to grasp the concept of the multidimensionality of the artistic process. Through focusing on metaphors, memories, feeling, colors, dreams, and more, the women slowly started to become conscious of how vast a world this was. They started to understand that the world on the inside is immense.

In contemporary terms, students got to know their hard disc. They started to make the connection between the "holy" world of art and what art was for them, what their own art was like. They started to understand the choices famous artists like Joan Miro, Henri Matisse, or Robert Rauschenberg made. All the participants of the workshop had moments of a breakthrough during the course by doing something they had never done before. These breakthroughs were always related to trying out new materials or new ways in art making.

For my students, development of their artistic voice expressed itself as a reawakening of the imagination and its associative power, as well as a sensitization of visual thinking that paralleled an increase in daring to try new techniques and new combinations of imagery and materials. I was surprised to realize that the whole process of development of artistic ability starts as a cognitive process. Understanding that there is a cognitive process at the base of artistic development is crucial for adult art education. It means that especially adults can learn how to make art because of their developed ability to reflect (in comparison to children).

Acquiring Self-Knowledge through Artistic Expression

> I learn. I learn about myself. In all that I learn, I also learn about myself.
> My sensitivities, my memories, my feelings.
> —Tina

The development of artistic voice also involved a development on a personal level. Becoming an artist implies becoming aware of one's self. The process of development implies an unfolding, a getting to know yourself, a process of starting to see and understand. It means meeting wisdom but also immaturity. This is not always easy, and not everybody is ready to face who she is. It means acceptance and honesty toward our history of self. The student's greatest enemy is herself because instead of letting it all happen and going with the flow, her fixed mind-sets—about herself as a person, her art making, her abilities—often stand in the way of exploration and discovery. The defense mechanism of the little girl works full speed to avoid the pain of failure and criticism.

Adults lean strongly on their rational thinking—so strongly that they often don't want to write about exploration of their thoughts concerning their issue of personal interest. It gives them fear. Becoming an artist means giving image, shape, and color to memories, dreams, and hopes—but also to fears and painful thoughts. In order to develop artistic voice, you must start at the very beginning. The very beginning of making art, of expressing yourself, is the very beginning of meeting with one's self.

During the workshop, participants were immersed in a deep process of communicating with the self and acquiring self-knowledge through artistic expression, because they worked on an issue of personal interest. The assignments that encouraged the women to recall images from memories, feelings, and dreams and find personal metaphors led the women to look at different sides of themselves. Once they surrendered to this approach (it took them a few sessions), they indulged in the affluence of the visual material they found. In the first sessions, some insisted they couldn't see any images behind words, but the fact they "discovered" feeling ("What does it feel like?") opened doors. Discovering the link between colors and feelings helped a lot in this (What is the color of boredom, of frustration? What feeling is lime, blue gray, orange?).

The focus of the workshop was the generation of an issue of personal interest, so feelings played a paramount role as a tool to zoom in closely on images. The three women I monitored all refer to "deeper feeling," a result of really trying to feel this self-chosen issue of personal interest. Interactive, dialogical questioning prompted students' diverse interpretation of feelings. We spent a whole session talking as a group about the colors that different feelings have and the feelings behind the colors, and the women were genuinely surprised by each other's responses. Colors helped very well to sensitize students to feelings.

When I started the workshop, I wondered whether there would be any changes in experience of self-identity as the women worked on an issue of personal interest. During the weekly sessions, I monitored developments in knowledge, understanding, and insight of the women's self-awareness and of their personal narratives of self (what is meaningful for them), as development of their self-identity. I listened carefully to them in interactive discussions and one-on-one communications. I asked the three women for their own experience in the interview I had with them. Obviously, working on an issue of personal interest induced a continuous self-reflection.

> I go deeper. I search for things constantly. It helped me to go deeper. I think about my theme constantly, and I think about other collages that I could make. I touch it more. There is more focus. I go to a deeper level. I saw things in myself that I hadn't realized.
> —Markella

As the workshop evolved, intricate relations became visible between the development of the women's artistic ability and the development of their self-identity. These phenomena are very much interrelated: when the imagination awakes and the artistic ability of a person develops, the whole self is activated; thinking becomes deeper, the person starts to feel more and discovers her own colors, shapes, and metaphors, and the inner world comes to life. Working on an issue of personal interest sensitized the women on all levels: cognitive, emotional, and artistic. Consequently, there was another interesting development visible toward the end of the workshop. The women discovered layers in their personalities. Markella discovered that under anger was despair, violence, and fear. By going back and forth between reflection, searching for images, and making collages, the women discovered these layers. Anna even experienced a therapeutic effect of visualizing and making art.

> The more I gave it a name, the more I got away from the shadow. And I became more balanced. That's why I started to use the doll and the face. It helped me a lot. I worked it out; I got it out of me. And the shadow started to open. And in a certain moment, you said, "What is under that shadow?" And my collages became lighter because it fell off me, because I gave it a name and shared it.
> —Anna

Through the focused, step-by-step art-making process, the women discovered their personalities through self-reflection, and they acquired self-knowledge. Making art reveals what is there, makes the images visible, and activates the inner world. It stimulates integration of imagination, thinking, and feeling, and this produces inspired artwork. Tina experienced a kind of transformation when she focused intensively on "Memories of Feelings of Women."

The process of artistic development can help women become who they really are and discover their true self-identity. Especially for women, it is mandatory to discover who they really are and accept themselves the way they are in order to enjoy the beauty, worth, and meaning of their own lives. They should not be dependent on the opinions or judgments of others (men and women) in their lives. Getting to know yourself and becoming aware of who you are is the key to personal power, individuation, having a dialogue with oneself, and having a voice.

Art making is a practical tool for women to discover who they are because it provides a visual process to discover what is important to them and what they are passionate about. Making art is integrative: it works on all levels of the human psyche and gives tactile results of the process. Collage making is an especially easy way to start artistic explorations. Some of my students couldn't draw or paint, but they developed their ability to cut and paste photographs and colored shapes and to choose color for their artwork because they were able to consciously look for the images they wanted or the colors that felt right. Art making gives women the possibility to monitor their own progress in expressing who they are. I wanted to know more about the process of artistic development and its relation to the development of self-identity because I felt art was a way to help women become who they really are, discover their true self-identity, and see how art making is a way to cultivate themselves and to grow. It is a way to discover one's own voice, to believe in it and to develop it.

What has become clearer concerning your personal artistic development?

> Clearer? Well, you know, what has happened to me. That I have to work. Really, you have to work. Nothing happens without work; that is clear every time you do something small. And maybe you don't make big steps, but you move. Maybe you stay in the same place, but the movement brings result. I have understood this.
> —Tina

> That it is easier to do what before seemed to me like a mountain. That I couldn't express myself without the interference of my mind.
> —Markella

> That I make my collages step by step, moment by moment, and I see where it takes me. Without thinking that I have to make a beautiful image. Already, with some collages I made in the beginning, I began to think that I could do those again in a different way. And that probably means I'm

going to another phase. I see that the old ones I can do that in another way, I can do that even better. So I am developing myself—that is certain.
—Anna

Markella describes it as follows.

How has your work developed over the last few months?
I think there was an improvement, a development. I started off ... lousy. I wasn't good. I felt really bad. My work was bad, I felt it, and I understood I couldn't express what I really wanted. And even now, I don't know if the results are good. If an experienced collage artist would judge them, I don't know if he would think they were worth anything ... but at least I am able to express my feelings now. I am "unstuck" from some things. I became inspired.

Like what?
From logical thinking. Before, I would think, It doesn't say anything, it doesn't work logically, it doesn't go. It doesn't fit. It doesn't say anything. Now, I let it work by itself. Whatever happens.

And the criterion now has changed?
The criterion is if I like it, if I like the end result. It might not be as clear as if I worked it out logically, but the aesthetic result is better, and it definitely expresses meaning now.

I have realized a change that I consider is big for me. A change that is happening now. Before, I used to make collages, and the style of every collage was analogous to the kind of pictures I found. They were very different from each other in style, like I was looking for something. Now, my own images arise from me more easily, and I use much more my own images, and the result is a much more integrated style.
—Anna

This is the essence of developing personal artistic voice: the discovery of a personal visual language where your beliefs, life philosophy, and self-identity are interwoven with your art. Working with those ideas, images, and feelings that are most meaningful to you will be pivotal in developing your personal artistic voice and lead to your empowerment as a woman. Find what you feel passionate about, write about it, and visualize it in your art!

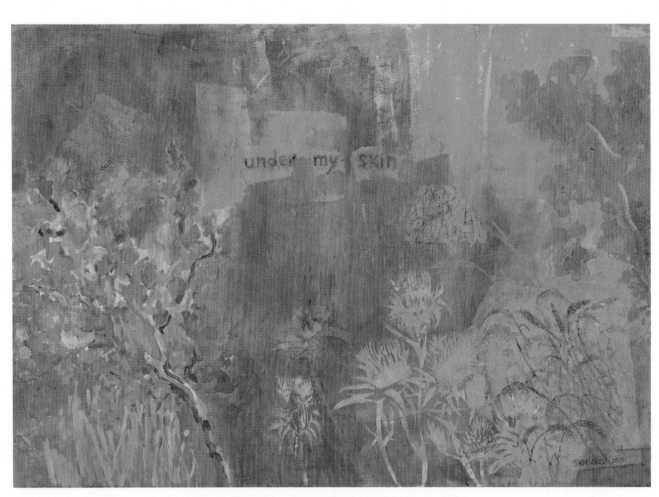

Sophia Kyriakou, *Under My Skin*, 2016, mixed media

7. For Further Work

I hope you enjoyed these first twelve sessions on your path toward developing your personal artistic voice! Of course, it doesn't end here—this was just the beginning. But it is important to establish this method inside you in order to proceed from here. The word *method* comes from the Greek μέθοδος, which means "the road you should take to get there." The method here is writing down your story, using your Inner-Net in order to browse for personal images behind the words you used, zooming in on specific sections of your inner world (e.g., metaphors, memories, feelings, colors, dreams and nightmares, spirituality, abstract shapes and materials), and using those images for inspired and meaningful art making. This is the work on the inside (or inner side) that needs to be practiced before you can go to the next step, which is being inspired by the outside world. Doing research online about your issue, going to exhibitions and museums, and browsing libraries and bookshops will give you information and ideas for new projects. Which artists work around your issue? Which authors or poets have written about it? What stories concerning your issue can you find in films? What moves you or captivates you during this research? It is important that you let the work of other artists inform your art, using some aspects of their art-making process for your own work. Well-established artists usually have very precise artist statements, and it is useful to read them and get ideas for your own artist statement.

Many artists combine being inspired by personal life experiences with world literature or poetry. They use religious or spiritual concepts, or they turn to nature for specific shapes, compositions, or processes and let these inspire their art. Video artist Bill Viola's themes are birth, death, and the unfolding of consciousness. He is inspired by Eastern and Western art, literature, philosophy, and spiritual traditions, including Zen Buddhism, Islamic Sufism, and Christian mysticism. His video *Ocean Without a Shore*[57] explores the idea of reincarnation. It takes its title from twelfth-century Andalusian Sufi mystic Ibn Arabi, who wrote, "The Self is an ocean without a shore. Gazing upon it has no beginning or end, in this world and the next." The work was inspired by a poem of twentieth-century Senegalese poet and storyteller Birago Diop,[58] who recorded traditional oral folktales of the Wolof people. In this poem he describes the breathing of the forefathers in the sounds of nature.

Established artists can show you the way. Find a workable theme and a title for a body of work you want to make. It works sometimes to start with a title and let it lead you to work that is purely your own! Do research into sources that make your heart beat faster; ponder on songs, poems, films, or books that might be related. The outlines of your new body of work will start to appear. Work a bit every day, but take your time. It usually takes three years before your new work is ready!

By now, you might have found a theme or issue that could lead you to a full-bodied work of art. Even if you are still searching, you can browse your mind or do some research to find writers, philosophers, artists, scientists, or poets who can inform your work with ideas, give your work depth, place it in a wider context, and give it more shine because you found that one poem, that one writer, or that one scientific idea that gives your artwork that little bit extra and makes it stand out due to its originality and depth.

Being creative is, after all, conceiving, developing, or discovering unique connections between one thing and another. Creativity is our ability to take elements from our world and arrange them into something completely new and unique. It begins with an idea in our minds and ends with a tangible artwork that other people can enjoy. Being an artist is an exciting journey. It is challenging, but when you manage to work with doubt and fear on your side, you will go through an artistic process of self-discovery and self-realization that is absolutely worth it!

Appendix A
Feelings When Your Needs Are Satisfied[59]

Affectionate

compassionate

friendly

loving

open hearted

sympathetic

tender

warm

Confident

empowered

open

proud

safe

secure

Engaged

absorbed

alert

curious

engrossed

Excited

amazed

animated

ardent

aroused

astonished

dazzled

eager

energetic

enthusiastic

giddy

invigorated

lively

passionate

surprised

vibrant

Exhilarated

blissful

ecstatic

elated

Joyful

amused

delighted

glad

happy

jubilant

pleased

tickled

Peaceful

calm

clear headed

comfortable

centered

content

equanimous

fulfilled

mellow

quiet

relaxed

relieved

enchanted

entranced

fascinated

interested

intrigued

involved

spellbound

stimulated

Inspired

amazed

awed

wonder

enthralled

exuberant

radiant

rapturous

thrilled

Grateful

appreciative

moved

thankful

touched

Hopeful

expectant

encouraged

optimistic

satisfied

serene

still

tranquil

trusting

Refreshed

enlivened

rejuvenated

renewed

rested

restored

revived

Appendix B
Feelings When Your Needs Are Not Satisfied[60]

Afraid	Disconnected	Pain
apprehensive	alienated	agony
dread	aloof	anguished
foreboding	apathetic	bereaved
frightened	bored	devastated
mistrustful	cold	grief
panicked	detached	heartbroken
petrified	distant	hurt
scared	distracted	lonely
suspicious	indifferent	miserable
terrified	numb	regretful
wary	removed	remorseful
worried	uninterested	
	withdrawn	**Sad**
Annoyed		depressed
aggravated	**Disquiet**	dejected
dismayed	agitated	despair
disgruntled	alarmed	despondent
displeased	discombobulated	disappointed
exasperated	disconcerted	discouraged
frustrated	disturbed	disheartened

impatient

irritated

irked

Angry

enraged

furious

incensed

indignant

irate

livid

outraged

resentful

Aversion

animosity

appalled

contempt

disgusted

dislike

hate

horrified

hostile

repulsed

perturbed

rattled

restless

shocked

startled

surprised

troubled

turbulent

turmoil

uncomfortable

uneasy

unnerved

unsettled

upset

Embarrassed

ashamed

chagrined

flustered

guilty

mortified

self-conscious

Fatigue

beat

forlorn

gloomy

heavy hearted

hopeless

melancholy

unhappy

wretched

Tense

anxious

cranky

distressed

distraught

edgy

fidgety

frazzled

irritable

jittery

nervous

overwhelmed

restless

stressed out

Vulnerable

fragile

Confused

ambivalent

baffled

bewildered

dazed

hesitant

lost

mystified

perplexed

puzzled

torn

burnt out

depleted

exhausted

lethargic

listless

sleepy

tired

weary

worn out

guarded

helpless

insecure

leery

reserved

sensitive

shaky

Yearning

envious

jealous

longing

nostalgic

pining

wistful

Relevant Books

de Beauvoir, S. 1953. *The Second Sex.* London, UK: Jonathan Cape.

Belenky, M., et al. 1986. *Women's Ways of Knowing: The Development of Self, Voice and Mind.* New York, NY: Basic Books.

Bird, J., J. A. Isaak, et. al. 1996. *Nancy Spero.* New York, NY: Phaidon.

Chicago, J. 2014. *Institutional Time: A Critique of Studio Art Education.* New York, NY: Monacelli Press, LLC.

Csáky, M., et al. 1979. *How Does It Feel? Exploring the World of Your Senses.* New York, NY: Harmony Books.

Efland, A. D. 2004. "Art Education as Imaginative Cognition." In W. E. Eisner and M. D. Day (eds.), *Handbook of Research and Policy in Art Education.* Mahwah, NJ: Lawrence Erlbaum Associates, Inc.

Galleria Civica d'Arte Moderna e Contemporanea Turin. 2007. *Collage/Collages from Cubism to New Dada.* Milan: Montadori Electa.

Gardner, H. 1990. *Art Education and Human Development.* Los Angeles, CA: J. Paul Getty Trust.

Gilligan, C. 1982. *In a Different Voice: Psychological Theory and Women's Development.* Cambridge, MA: Harvard University Press.

Grosenick, U. 2001. *Women Artists.* Cologne: Taschen

hooks, b. 1994. *Teaching to Transgress: Education as the Practice of Freedom.* New York, NY: Routledge.

Jordon, J. (ed.). 1997. *Women's Growth in Diversity: More Writings from the Stone Center,* New York: Guilford Press.

Lavin, M. 1993. *Cut with the Kitchen Knife: The Weimar Photomontages of Hannah Höch.* New Haven, CT: Yale University Press.

Lowe, S.M. 2006. *The Diary of Frida Kahlo: An Intimate Self-Portrait.* New York, NY: Abrams Books.

Miller, J. B. 1986. *Toward a New Psychology of Women.* Boston, MA: Beacon Press.

Nochlin, L. 2002. "Joan Mitchell: A Rage to Paint," In Jane Livingston (ed.), *The Paintings of Joan Mitchell.* New York, NY: Whitney Museum of American Art.

Pearlman, S. F. 1993. "Late Mid-life Astonishment: Disruptions to Identity and Self-Esteem." In: N. D. Davis, E. Cole, and E. D. Rothblum (eds.), *Faces of Women and Aging.* Binghampton, NJ: The Haworth Press.

Pinkola Estés, C. 1992. *Women Who Run with the Wolves: Myths and Stories of the Wild Woman Archetype.* New York, NY: Ballantine Books.

Ringgold, F. 2005. *We Flew over the Bridge: The Memoirs of Faith Ringgold.* Durham, NC: Duke University Press Books.

Sandler, I. 2016. *Women of Abstract Expressionism.* New Haven, CT: Yale University Press.

Taylor, B. 2004. *Collage: The Making of Modern Art.* New York, NY: Thames and Hudson.

Whitechapel Gallery. 2014. *Hannah Höch,* London, UK: Prestel.

Tharp, T. 2003. *The Creative Habit. Learn It And Use It For Life.* New York, NY: Simon & Schuster Paperbacks

References

1. https://www.theguardian.com/lifeandstyle/the-womens-blog-with-jane-martinson/2013/may/24/women-art-great-artists-men

2. https://www.nytimes.com/2007/05/17/fashion/17Dating.html?_r=0.

3. L. Gunnarsson, "A Defence of the Category 'Women,'" *Feminist Theory* 12, no. 1 (2011): 23–37, *https://journals.sagepub.com/doi/pdf/10.1177/1464700110390604*.

4. https://www.theguardian.com/commentisfree/2012/oct/09/judy-chicago-women-artists-history.

5. First-wave feminism of the nineteenth and early twentieth centuries focused on women's legal rights, such as the right to vote. Second-wave feminism of the "women's movement" peaked in the 1960s and 1970s and touched on every area of women's experience—including family, sexuality, and work.

6. Founded in 1985, the Guerilla Girls are a New York–based group of artists, writers, performers, and film makers who fight discrimination.

7. S. F. Pearlman, "Late Mid-life Astonishment: Disruptions to Identity and Self-Esteem." In: N. D. Davis, E. Cole, and E. D. Rothblum (eds.), *Faces of Women and Aging* (Binghampton, NJ: The Haworth Press, 1993).

8. In the United States alone, $8 billion was spent on plastic surgery in 2016.

9. A. Byrne, "Developing a Sociological Model for Researching Women's Self and Social Identities." *European Journal of Women's Studies* 10, no.4 (2003): 443–464.

10. C. Gilligan, *In a Different Voice: Psychological Theory and Women's Development* (Cambridge, MA: Harvard University Press, 1982).

11. J. Chicago, J. *Institutional Time: A Critique of Studio Art Education* (New York, NY: Monacelli Press. LLC. 2014) Kindle edition, location 3992

12. A. McFadyen, *Bound to Sin: Abuse, Holocaust and the Christian Doctrine of Sin* (Cambridge, UK: Cambridge University Press, 2000).

13. b. hooks, *Teaching to Transgress: Education as the Practice of Freedom* (New York: Routledge, 1994).

14. In J. Jordon (ed.), *Women's Growth in Diversity: More Writings from the Stone Center* (New York: Guilford Press: 1997), 18.

15. https://www.nytimes.com/2007/05/17/fashion/17Dating.html?_r=0.

16. http://www.bl.uk/manuscripts/FullDisplay.aspx?ref=Arundel_MS_263.

17. https://en.wikipedia.org/wiki/Frida_Kahlo

18. S.M. Lowe, *The Diary of Frida Kahlo: An Intimate Self-Portrait* (New York: Abrams Books, 2006).

19. B. Taylor, *Collage: The Making of Modern Art* (London, UK: Thames & Hudson, 2004).

20. We will look at dada and artist Hannah Höch at the end of the first session.

21. We will look at surrealism and artist Eleonora Carrington at the end of session 5, the session on dreams.

22. https://fairuse.stanford.edu.

23. Whitechapel Gallery. *Hannah Höch*, (London: Prestel, 2014). https://en.wikipedia.org/wiki/Hannah_H%C3%B6ch

24. M. Lavin, *Cut with the Kitchen Knife: The Weimar Photomontages of Hannah Höch* (New Haven: Yale University Press, 1993), 211–215.

25. Dada was an artistic movement formed in 1919 in Zurich, Switzerland. Originally, it started as an antiwar movement (World War I). The movement rejected monarchy, militarism, and conservatism and was enmeshed in an anti-art sentiment. Dada had a tone of fundamental negativity in regard to bourgeois society. The term *dada* has no actual meaning; it is a childlike word used to describe the lack of reason or logic in much of the artwork.

26. https://www.scribd.com/document/79865551/To-Monogram-Ma-Odysseas-Elytis.

27. https://www.poetryfoundation.org/poets/odysseus-elytis.

28. http://www.baerbelhische.de.

29. https://books.google.gr/books?id=K_N3BgAAQBAJ&pg.

30. http://www.karawalkerstudio.com

31. https://walkerart.org/collections/artists/kara-walker

32. F. Wilson, "On Walls and the Walkers", *The International Review of African American Art* 20.3: 17–19.

33. http://www.frankenthalerfoundation.org

34. http://www.seniorwomen.com/news/index.php/helen-frankenthaler.

35. https://www.youtube.com/watch?v=x-1_5FGXFpE

36. I. Sandler, *Women of Abstract Expressionism* (New Haven: Yale University Press, 2016).

37. https://www.artmovements.co.uk/surrealism.htm.

38. https://www.wikiart.org/en/eileen-agar/angel-of-anarchy-1940.

39. https://www.leocarrington.com/quotes-citas.html

40. W. Chadwick, "Leonora Carrington: Evolution of a Feminist Consciousness". *Woman's Art Journal* (1986): 37–42.

41. https://en.wikipedia.org/wiki/Leonora_Carrington

42. Csáky, M. et al. *How Does It Feel? Exploring the World of Your Senses* (New York: Harmony Books, 1979)

43. https://en.wikipedia.org/wiki/Lee_Krasner

44. U. Grosenick (Ed.), *Women Artists* (Cologne: Taschen Ed., 2001)

45. http://sophiakyriakou.gr

46. https://en.wikipedia.org/wiki/Faith_Ringgold

47. https://m.theartstory.org/artist/ringgold-faith/

48. F. Ringgold, *We Flew over the Bridge: The Memoirs of Faith Ringgold* (Durham, NC: Duke University Press Books, 2005).

49. http://joanmitchellfoundation.org

50. Linda Nochlin, "Joan Mitchell: A Rage to Paint," In Jane Livingston (ed.), *The Paintings of Joan Mitchell* (New York: Whitney Museum of American Art, 2002), 55.

51. https://www.hauserwirth.com/artists/2783-ellen-gallagher

52. https://art21.org/artist/ellen-gallagher/

53. Ellen Gallagher Quotes. BrainyQuote.com, BrainyMedia Inc, 2019. https://www.brainyquote.com/quotes/ellen_gallagher_656915, accessed October 20, 2019.

54. J. Bird, J. A. Isaak, et al., *Nancy Spero* (New York, NY: Phaidon, 1996).

55. http://exhibitions.globalfundforwomen.org/exhibitions/celebrating-women/ingredients-peace

56. https://en.wikipedia.org/wiki/Nancy_Spero

57. Bill Viola, *6' Ocean without a Shore*, https://www.youtube.com/watch?v=6-V7in9LObI.

58. http://quaker.org/legacy/poplar/messages/20150301_Forefathers.pdf

59. The Center for Non-violent Communication https://www.cnvc.org/sites/default/files/feelings_inventory_0.pdf

60. The Center for Non-violent Communication https://www.cnvc.org/sites/default/files/feelings inventory 0.pdf

About the Author

Annette Luycx

Annette Luycx, MEd, MSc, is an artist and freelance art educator from the Netherlands living and working in Greece. She has taught collage, mixed media, and ceramics in Athens to people of all ages and abilities for the past twenty years at schools and cultural centers. She is specialized in artistic coaching and artistic talent development. The purpose of her teaching practice is to support artists, art students and creatives in gaining increased self-awareness and understanding of their individual creative process, as well as to promote artistic growth and development of their artistic voice. She has been studying and exploring the link between artistic expression and self-awareness in the visual arts, dance, and theater her whole life. In 2014 she created the IRIS ART CENTRE, a center for adult art education specialized in the development of personal artistic voice. Here, she organizes summer art workshops and artist coaching residencies, in the Greek countryside about twenty miles north from the center of Athens. www.irisartcentre.com

Annette Luycx holds a master's degree in sociology and women's studies from the University of Amsterdam, a postdoctoral degree in cultural management from Paris Dauphine University, and a master's degree in art education from the Maryland Institute College of Art (MICA). She has traveled extensively and studied fine arts, theater, and ceramics with international artists and art educators. She has participated with collages, photomontages, prints, and ceramics in group exhibitions in Amsterdam, Athens, Boston, Baltimore, Edinburgh, Salzburg, Prague, and Paris. www.annetteluycx.com